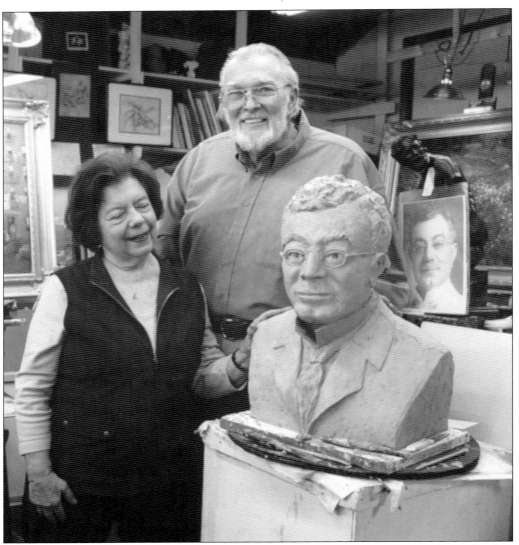

In 2011, Temple City resident Vic Riesau was commissioned to create a bronze bust of Walter P. Temple, founder of the town. In this photograph, Riesau and Temple's granddaughter Josette admire the finished product. The sculpture now sits on the entrance monument at Temple City Park. (Courtesy Temple City Photos.)

ON THE COVER: This photograph highlights the beginning of the 10th Camellia Parade. The year 1954 was an outstanding one for the parade with 51 floats and 5,000 participants marching down Las Tunas Drive. The parade was held on Saturday morning followed by a carnival on Saturday afternoon and Sunday. (Courtesy Temple City Camellia Festival.)

IMAGES of America
TEMPLE CITY

Donna Georgino and the
Historical Society of Temple City

Copyright © 2025 by Donna Georgino and the Historical Society of Temple City
ISBN 978-1-4671-6196-1

Published by Arcadia Publishing
Charleston, South Carolina

Printed in the United States of America

Library of Congress Control Number: 2024937739

For all general information, please contact Arcadia Publishing:
Telephone 843-853-2070
Fax 843-853-0044
E-mail sales@arcadiapublishing.com

Visit us on the Internet at www.arcadiapublishing.com

This book is dedicated to all the people of Temple City, past and present, who have created this wonderful place to live.

Contents

Acknowledgments　6

Introduction　7

1. Temple Family and Friends　9
2. Temple Townsite Company Era　17
3. First 50 Years　49
4. Temple City Schools　65
5. Camellia Festival　93
6. The 1980s to Now　115

Acknowledgments

When not otherwise indicated, the photographs in this book are from the collection of the Historical Society of Temple City. Special thanks to the board of directors and members of the Historical Society of Temple City who contributed to this book in numerous ways.

Some of the most important donations came from the Temple City Camellia Festival and the Temple City Unified School District. Their archives of photographs, newspaper articles, and written documents played a significant role in conveying the history of Temple City. The Camellia Festival provided photographs that depict the spirit of the community since 1944. The Temple City Unified School District's archives, especially those from 1908 to 1961, demonstrated why Temple City's schools have become the heart of the community.

Special thanks to Jerry Jambazian, the creator of Temple City Photos and owner of Wonder Cleaners, who has been photographing the community for over 20 years. Jerry was instrumental in providing historical information and scanning photographs to be used in this book. Without his assistance and his 70 years of knowledge of Temple City's history, there would have been many gaps in the story.

This book would not have been complete without including some of the history of the Workman and Temple families. Much of the information on the families was provided by the Workman and Temple Family Homestead Museum. Museum director Paul Spitzzeri's wealth of knowledge and willingness to share was an invaluable resource.

Another important partner was the City of Temple City, including the city council and city staff. Their support and cooperation inspired the historical society to take on this project. Other individuals deserving of a mention for their contributions to this book are Javier Salazar, Riley Saxon, Dawn Tarin, Mary Sneed, Darryl Fish, Susana Capra, Iliana Flores, and Vinson Bell.

In a close-knit community like Temple City, some may wonder why certain events were included and others were not. In most cases, the events highlighted in the book were those in which photographs and supporting information existed. In a few cases, editorial decisions had to be made to ensure that a comprehensive story could be told.

Introduction

The Workman and Temple families arrived in Southern California in the 1800s. At their peak, they were two of the most prominent families in the Greater Los Angeles area. From Jonathan Temple establishing the first store and first theater in Los Angeles to the numerous acres of land owned by various family members, their impact on the development of the Southwest is undeniable. Throughout the years, various family members were also influential in local politics, serving on the Los Angeles County Board of Supervisors and the Los Angeles City Council and as Los Angeles mayor.

After his nine-year-old son Thomas discovered oil on their Montebello Hills property in 1914, Walter P. Temple purchased a 285-acre piece of land located in the northwest section of Rancho San Francisquito. Temple's father and grandfather had once owned the property, but it was forfeited to Elias J. "Lucky" Baldwin after the Long Depression of the 1870s. Temple and his business associates speculated that this rural piece of land in the San Gabriel Valley could become a vibrant middle-class community. In 1923, the Temple Townsite Company was formed, and the town of Temple was founded. The development of the town was marked by the adoption of restrictive racial and class covenants, including exclusions limiting property ownership to "white people of a desirable class." At the time, these socially acceptable policies were commonplace throughout most of California, and in Temple City, they played a significant role in shaping the ethnic composition of the community. Temple City has evolved significantly from its early days and is now an ethnically diverse city reflecting the multiethnic members of the Workman and Temple families.

A few years after the founding of the town, it was determined that the name "Temple" caused confusion at the post office. A contest was held, and the name "Santa Rita" was chosen. Not everyone liked the winning name, so after much debate, it was decided in 1928 to compromise and change the name to "Temple City." In the late 1920s, the implementation of the Mattoon Act and the Great Depression brought many economic challenges to Walter Temple and the Temple Townsite Company. By 1930, Temple had abandoned his efforts to develop the town, and he could no longer afford to live in the family homestead in Rancho La Puente. He moved to Mexico for a few years, and the homestead was lost to foreclosure. Eventually, he ended up living in a small house in a Los Angeles rear yard where he died in 1938 after a lengthy illness. Temple was buried at the Mission San Gabriel after the bank that owned the family homestead refused to let him be interred in the mausoleum. To preserve the historic site, the City of Industry purchased the family homestead, restored it, and opened it to the public in 1981. Temple's granddaughter Josette had his remains moved in 2002 to El Campo Santo, the homestead cemetery and mausoleum where other members of the Temple and Workman families were buried.

Despite the poor economic climate that forced Walter Temple to abandon the town bearing his family's name, Temple City persevered and continued to attract businesses and residents to the community. By 1948, the population had reached 24,000, and Las Tunas Drive was lined

with businesses from border to border. The 1940s saw the Woman's Club of Temple City choose the camellia as the city flower, and "Home of the Camellias" as the city motto. The Camellia Festival, a youth-focused community celebration that encouraged children to be involved in youth organizations, began in 1944. It grew quickly and soon included a parade, carnival, and a royal court of children. In 2024, the still-popular community event celebrated its 80th anniversary.

The school system grew along with the town, especially post–World War II. In a 10-year period beginning in 1947, five schools were added to the Temple City school system. In 1954, the voters decided to unify the school district, which allowed Temple City to build its own high school. The schools in the Temple City Unified School District brought much acclaim to the city in the years that followed. In the 1970s, Temple City High School's football team won seven California Interscholastic Federation championships and tied the California state record for consecutive wins, a streak that spanned four years. With exceptional Temple City High School graduates such as astronaut Steve Lindsey, the first blind physicist Kent Cullers, award-winning children's book author LeUyen Pham, and World Cup soccer player Jimmy Conrad, the schools became the crown jewel of the community and an important reason families moved to Temple City. Today, all Temple City schools have been designated "California Distinguished Schools," and in 2023, Temple City Unified was given an A-plus grade by Niche.

In 1960, the community voted to incorporate bringing about a new era of self-governance for Temple City. The first mayor was Merrill Fitzjohn, owner of a jewelry store on Las Tunas Drive. The inaugural city council members were sworn in on the new football field at Temple City High School. Another important development in the city was the establishment of the Historical Society of Temple City in 1987. The first Temple City Museum opened in a small city-owned building at Live Oak Park in 1999. The museum remained at the park until the Woman's Club offered its building on Kauffman Avenue as a permanent home in 2006.

During the 21st century, Temple City experienced its biggest challenges since the tough economic times of the 1920s and 1930s. A massive windstorm with hurricane-force winds pummeled the San Gabriel Valley in 2011, and Temple City was especially hard hit. The storm caused millions of dollars in damages and knocked out the electricity of many residents for several days. Nine years later, Temple City dealt with the COVID-19 worldwide pandemic, which closed businesses, forced schoolchildren to learn online for over a year, and paused the community events that had made Temple City so special. Even with all the difficulties throughout the past 100 years, Temple City, with a population today of 36,000, has maintained its hometown feel and is one of the most desirable places to live in the San Gabriel Valley.

One

Temple Family and Friends

In 1841, Francisco Pliny Fisk "F.P.F." Temple left Massachusetts for Los Angeles to join his older half-brother Jonathan, whom he had never met. Jonathan Temple owned the first store in Los Angeles and gave his younger brother a job as a clerk. Shortly after F.P.F. Temple arrived in Los Angeles, William Workman and John Rowland left New Mexico for Los Angeles via the Old Spanish Trail. Once in Southern California, both Workman and Rowland received land grants. In 1845, F.P.F. married Antonia Margarita Workman, the daughter of William Workman. Workman gave his new son-in-law land that F.P.F. and his wife used to establish a home. The Temples had 11 children, the 10th being Walter P. Temple (born 1869), future founder of the town of Temple. Over the years, F.P.F. and his father-in-law had many investments together, including a bank in Los Angeles. In 1875, the bank ran into financial difficulties when the "Long Depression" struck California. To save the bank, Temple and Workman borrowed money from Elias J. "Lucky" Baldwin and used their land in Rancho San Francisquito as collateral. Unsuccessful, they were forced to forfeit their land, driving Workman to commit suicide.

At age 23, Walter Temple inherited 50 acres of land in the Whittier Narrows from his mother, Margarita. In 1903, he married Laurenza "Laura" Gonzalez and had four children who lived into adulthood. With help from his friend and business manager, Milton Kauffman, the Temples were able to obtain 60 acres of land in the Montebello Hills from the estate of Lucky Baldwin. In 1914, Temple's nine-year-old son Thomas discovered oil on his family's property. Walter Temple leased his land to the Standard Oil Company of California, enabling the now wealthy Temples to purchase 75 acres of the Workman homestead. The Temples broke ground on their future home, which they referred to as La Casa Nueva, "the new house." Unfortunately, Laura passed away at the end of 1922 prior to construction being completed. Today, the 12,400-square-foot Spanish Colonial Revival mansion, along with Workman's home, are open to the public at the Workman and Temple Family Homestead Museum.

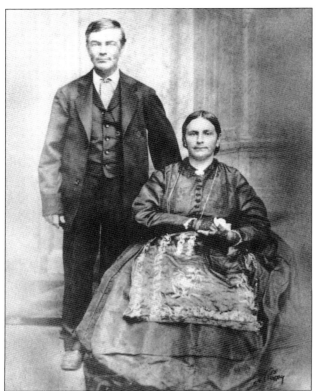

F.P.F. Temple, the father of the founder of the town of Temple, is pictured with his wife, Antonia Margarita Workman Temple. Temple served on the first Los Angeles County Board of Supervisors and as the Los Angeles City treasurer. The Temple and Workman families were at one time two of the most prominent families in Southern California. (Courtesy Workman and Temple Family Homestead Museum.)

The Workman adobe was built in 1842. It was enlarged over the years and, by 1870, was remodeled with the addition of brick wings and a second story as well as impressive exterior decorative details. After the stock market crash, the house was used as a boys' school and then a hospital until the City of Industry purchased it. (Courtesy Workman and Temple Family Homestead Museum.)

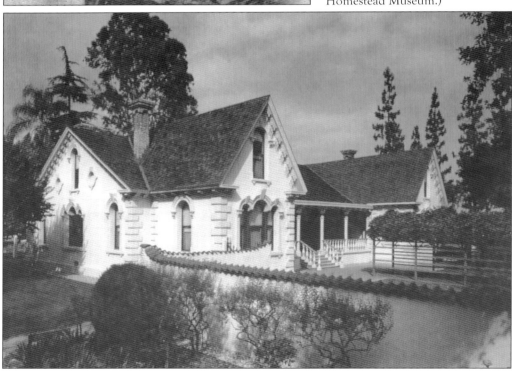

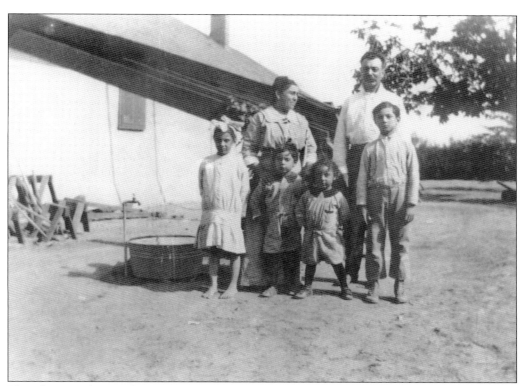

This photograph was taken in 1914 before Walter P. Temple became wealthy from the discovery of oil. Temple and his family lived a modest life on the 60-acre property that had been purchased from the estate of Lucky Baldwin. In the background is the adobe that the family lived in. (Courtesy Workman and Temple Family Homestead Museum.)

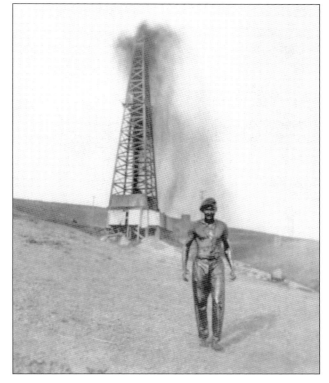

In 1919, Temple's property in the Montebello Hills was producing oil and providing the family with an affluent lifestyle. After oil was discovered, the family moved briefly to Monterey Park and then settled in Alhambra. Pictured is a worker covered in oil from one of the gushing oil wells. (Courtesy Workman and Temple Family Homestead Museum.)

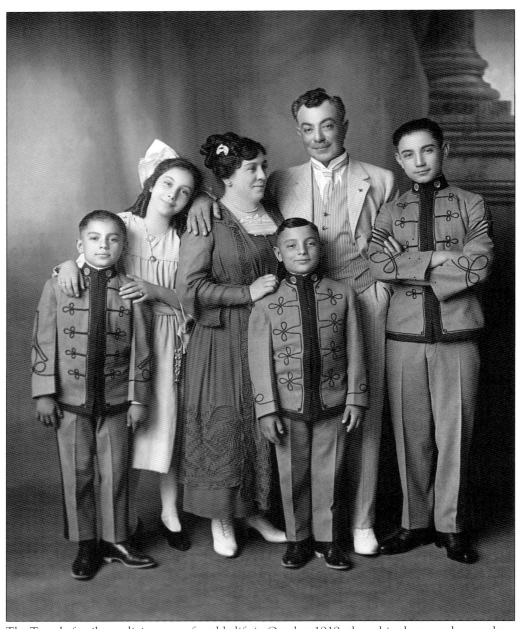

The Temple family was living a comfortable life in October 1919 when this photograph was taken. Pictured with Walter and his wife, Laura, are their children, from left to right, Walter Jr., Agnes, Edgar, and Thomas. All four children attended private schools and completed their education just prior to their father's financial misfortunes in the late 1920s. (Courtesy Workman and Temple Family Homestead Museum.)

Walter and Laura Temple had a 15-year courtship prolonged by the fact that Walter's family was not in favor of their relationship. Married in 1903, they remained married for almost 20 years until Laura died of colon cancer. During their marriage, Walter and Laura had five children, one of whom died as an infant. (Courtesy Workman and Temple Family Homestead Museum.)

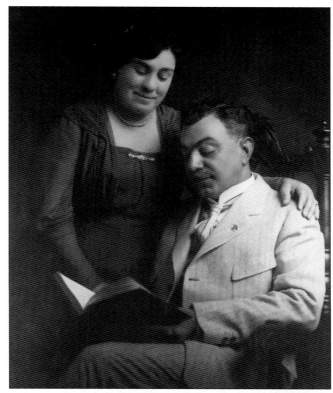

This formal family portrait of Walter Temple and his children was taken in 1926. The open space next to Walter was purposely there to signify where his late wife would have stood. Laura Temple died in 1922 at age 51. As a teenager, Laura worked for Walter's brother Francis, who had tuberculosis. (Courtesy Workman and Temple Family Homestead Museum.)

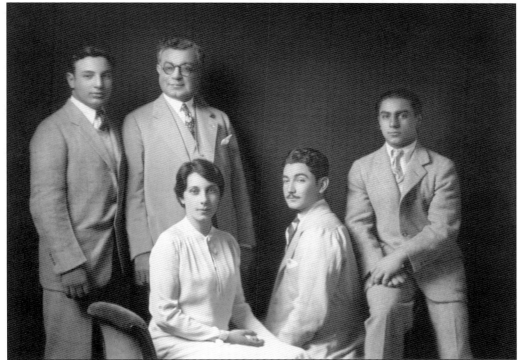

Milton Kauffman and George Woodruff were Temple's business partners in several projects, including the Temple Townsite Company. Woodruff also served as Temple's attorney, and Kauffman was his business manager. In this photograph Kauffman and his wife are on the left, Woodruff and his wife are in the center, and Walter Temple is on the right. (Courtesy Workman and Temple Family Homestead Museum.)

Sylvester Dupuy was a business associate of Walter Temple. In the 1920s, Dupuy built Pyrenees Castle in Alhambra. Years later, the castle was the site of the infamous murder of Lana Clarkson by Phil Spector. This is a photograph of the Dupuy and Temple families at the castle; Dupuy is in the center wearing a vest, and Temple is on the right. (Courtesy Workman and Temple Family Homestead Museum.)

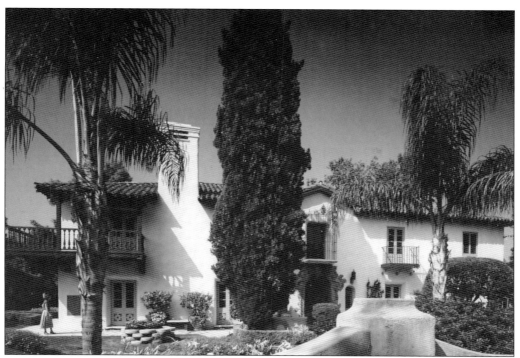

La Casa Nueva was the Spanish Colonial Revival home of Walter Temple. Construction of the home began in 1922 but was halted for a time due to the death of Laura Temple. On the one-year anniversary of Laura's death, the home was dedicated; however, construction was not completed until 1927. (Courtesy Workman and Temple Family Homestead Museum.)

Walter Temple Jr. only lived at La Casa Nueva for a brief time and never lived in Temple City, although he was connected to both his entire life. He died in 1998 at age 88 and is buried with his wife and parents in the family mausoleum at El Campo Santo. (Courtesy Workman and Temple Family Homestead Museum.)

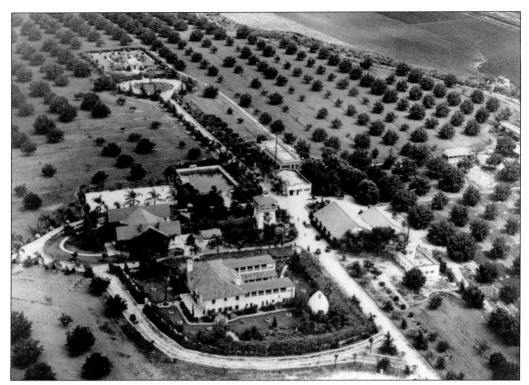

This photograph is an aerial view of the Workman and Temple homestead taken in the mid-1930s. The Workman adobe was built in 1842 by William Workman. La Casa Nueva was the Temple homestead built in the 1920s. El Campo Santo Cemetery and Mausoleum (at the top of the photograph) holds the remains of members of the Workman and Temple families. (Courtesy Workman and Temple Family Homestead Museum.)

This photograph of Walter Temple Jr. was taken in his bedroom at La Casa Nueva in 1988. Temple married Nellie Didier, and they had one daughter, Josette. Following in her father's footsteps, Josette was active in Temple City until her death in 2020. She was interred near her parents and grandparents at El Campo Santo. (Courtesy Workman and Temple Family Homestead Museum.)

Two

TEMPLE TOWNSITE COMPANY ERA

The Burkhard Investment Company owned 670 acres east of San Gabriel and had plans to establish a town they called Sunny Slope Acres. Instead, in 1921, Walter Temple purchased approximately half of the acreage to establish the town of Temple as a memorial to his pioneering family who were instrumental in the development of the Southwest. Along with his business manager Milton Kauffman, attorney George Woodruff, and good friend Sylvester Dupuy, they formed the Temple Townsite Company on May 26, 1923. The town of Temple was a "planned community" with a business district, park, large residential lots designed to be small ranches or farms for the middle class, and plans for a church and the extension of the Pacific Electric Red Car line to the center of the town. Bonds were issued to pave the roads, build sidewalks, and install utilities.

Soon after the founding of the town, residents began to form a community. The Temple Chamber of Commerce conducted an event to celebrate the town's first anniversary, the American Legion conducted armistice events, baseball teams played Sunday afternoon games, and the Town of Temple entered floats in the Pasadena Tournament of Roses Parade.

In late 1927, it was decided that the town needed a new name to avoid confusion at the post office. A contest was held, and a three-person committee was formed to select the winning name from over 200 entries. The winning name was "Santa Rita," and the anonymous person who submitted the name asked that the $25 prize money be given to Temple Community Church. Not everyone liked the winning name, including a local historian, J. Perry Worden, who wrote a letter to the editor of the *Temple Times* lambasting the idea. In the end, the postmaster announced that a compromise had been reached, and the new name would be Temple City.

There were several factors that contributed to the undoing of the Temple Townsite Company, including the stock market crash of 1929 and the Mattoon Act. As financial conditions worsened, Walter Temple and his associates sold their interest in the town in 1930.

The first meeting of the Temple Townsite Company was held on May 26, 2023. At the meeting, Walter Temple was elected president of the board of directors. Other members of the board were George Woodruff, Sylvester Dupuy, Milton Kauffman, and Dorothy Bingham. Although Bingham was named a director, she played no role in the operation of the company.

If not for R. Thornton Smith, there would be very few pictures of the early days of the town of Temple. Smith was born in Kansas City and made his way to California in May 1923. He was a real estate agent, a postmaster, and a photographer. His office was on Sunset Boulevard, in the same building as Cash Market. In this photograph, he is pictured with his wife, Elsie.

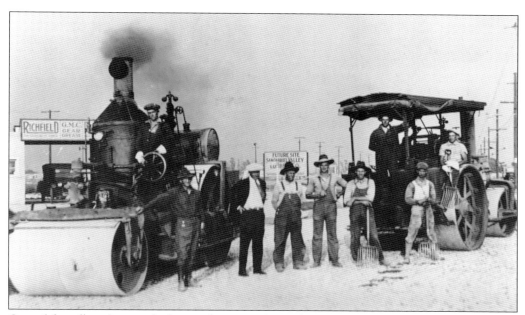

One of the selling features for lots in the town of Temple was the well-paved boulevards. Workers paved the two main thoroughfares, Main Street and Sunset Boulevard, with five-inch crushed rock and asphalt from curb to curb. All other streets in the tract were improved with sand, gravel, and oil pavement. (Courtesy R. Thornton Smith.)

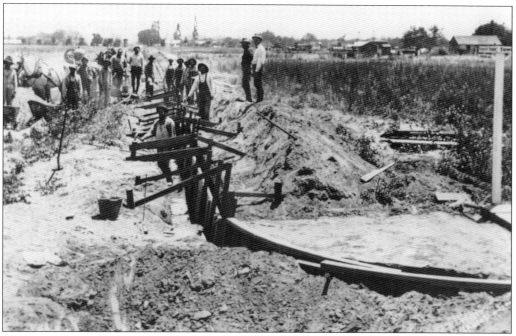

The major business district of the town of Temple was designed to have 12-foot cement sidewalks on each side of the street. The side streets had five-foot cement sidewalks with a seven-foot parkway between the sidewalk and curb. In this photograph, sidewalks are being installed on Ramona Avenue, which was later renamed Cloverly Avenue. (Courtesy R. Thornton Smith.)

TEMPLE IS PLANNED AS THE LOGICAL CENT[ER]

This is an early tract map of the town of Temple showing the layout of the original 285-acre community. The subdivision was bordered by Garibaldi Avenue on the north, Baldwin Avenue on the east, Encinita Avenue on the west, and Azusa Road on the south. In the first few years of the town, many of the street names were changed: Azusa Road was changed to Live Oak Avenue, Temple Avenue was changed to Camellia Avenue, Potter Avenue was changed to Oak Avenue,

OF A LARGE COMMUNITY DEVELOPMENT

Ramona Avenue was changed to Cloverly Avenue, and Dupuy Avenue was changed to Primrose Avenue. The area not part of the subdivision at Baldwin and Rowland Avenues was used as a baseball field for popular Sunday afternoon games. Also shown on the map are the tracks for the red car line, the streetcar turnaround, and the public park.

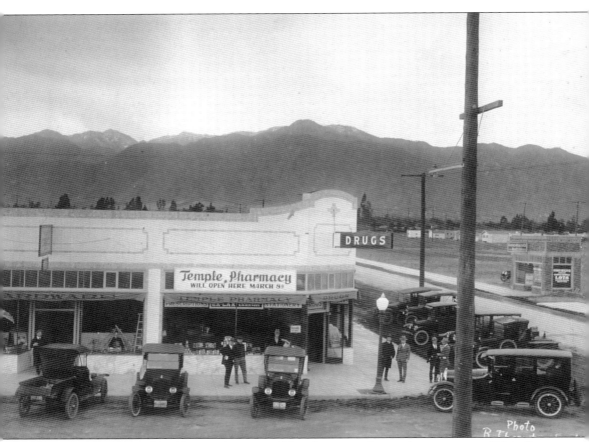

The first commercial building in the town of Temple was on the northwest corner of Main Street and Sunset Boulevard. It housed two businesses; Temple Hardware was owned by the Sears family and opened five days prior to Temple Pharmacy, thus becoming the first commercial business in the town of Temple. (Courtesy R. Thornton Smith.)

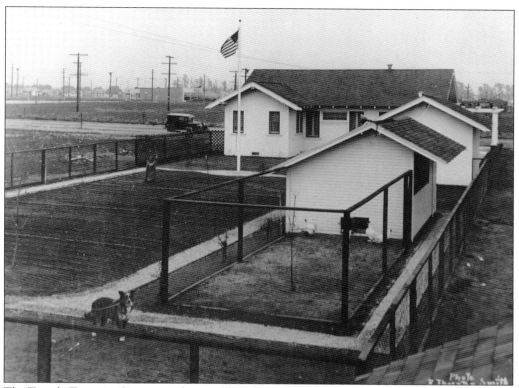

The Temple Townsite Company advertised lots that could be farms or ranches for the middle class. Pictured is the backyard of a model home on Cloverly Avenue with a garden and chicken coop. At the time, 50-foot lots sold for $1,200, and 100-foot lots sold for about $2,000. (Courtesy R. Thornton Smith.)

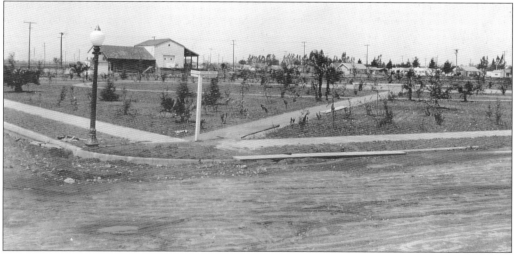

This is a photograph of the early days of Temple Park, taken from the corner of Golden West Avenue and Main Street. At the time, the streets had yet to be paved and the plants were too small to provide shade. In the background is the station for the Pacific Electric Red Car line. (Courtesy R. Thornton Smith.)

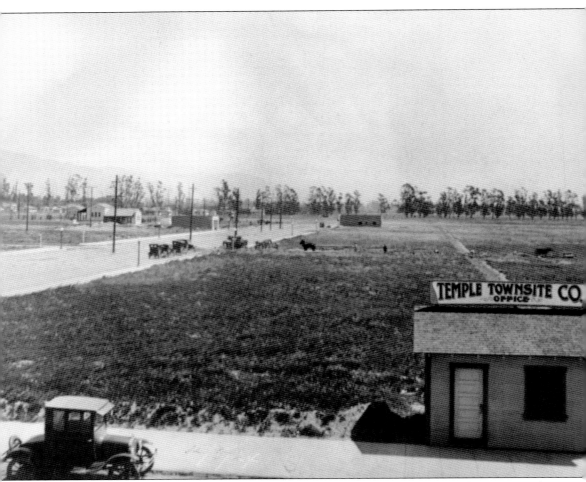

This photograph was taken shortly after the founding of the town of Temple. In the foreground is the Temple Townsite Company building, which was located on Sunset Boulevard, south of Main Street. In the background is the Pacific Electric Red Car station before the tracks were laid. The row of trees in the background was planted along Baldwin Avenue by Lucky Baldwin. (Courtesy R. Thornton Smith.)

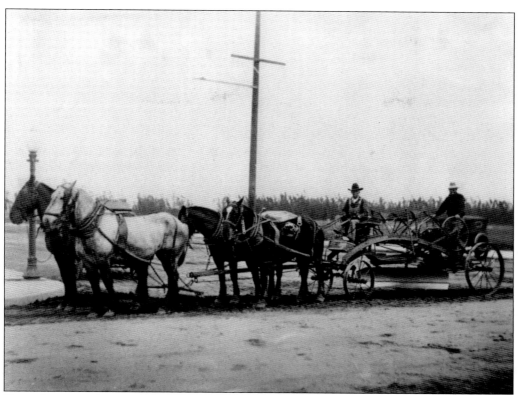

Horse-drawn graders were used to prepare Main Street for the installation of the tracks for the streetcar line extension. In this photograph, the teamster is sitting in the front to guide the horses, and the bladesman is in the back controlling the grading blade. Most of the initial construction of streets in the town of Temple was done with horses and manual labor. (Courtesy R. Thornton Smith.)

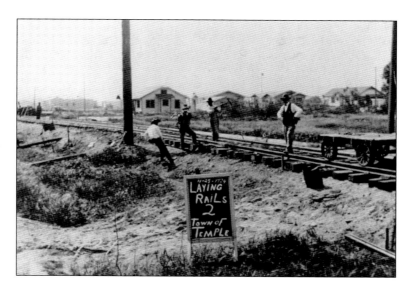

Extending the Pacific Electric Alhambra/San Gabriel Red Car line to the town of Temple was important to potential buyers because it ensured transportation to Los Angeles and reliable mail delivery. In this picture, taken in 1924, tracks are being laid east of Rosemead Boulevard along Main Street. (Courtesy R. Thornton Smith.)

25

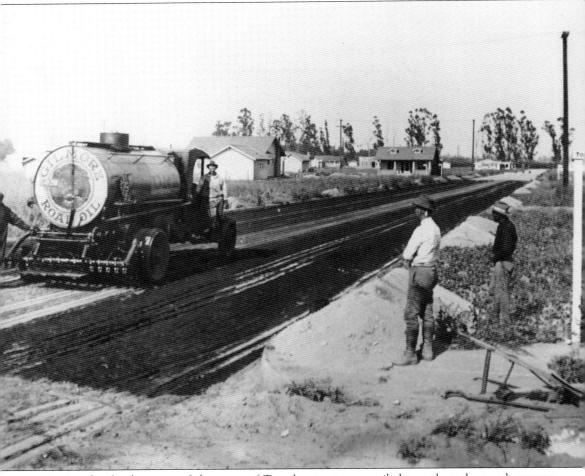

During the development of the town of Temple, streets were oiled to reduce dust and prevent erosion. This is a c. 1924 photograph of Woodruff Avenue taken at the intersection with Kauffman Avenue. The area on the bottom right of the picture is where the Woman's Club building was erected in 1941. (Courtesy R. Thornton Smith.)

Residential lots were suitable for building a cozy, comfortable, and attractive home with deep backyards. The purchaser would build-to-suit, which created neighborhoods of unique homes. This home was built in 1925 and is still in existence on the northwest corner of Kauffman and Workman Avenues. (Courtesy R. Thornton Smith.)

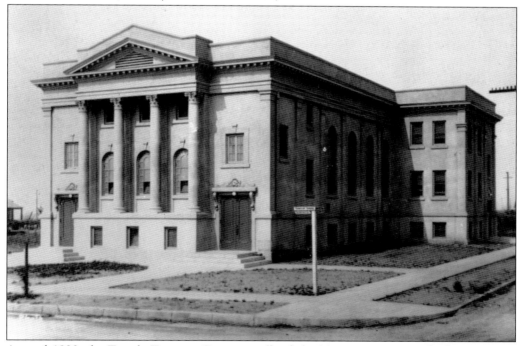

Around 1923, the Temple Townsite Company offered the Mountain View Methodist Episcopal church two lots for a church building and one for the parsonage on the southwest corner of Golden West and Woodruff Avenues. The church accepted and changed its name to Temple Community Church, Methodist Episcopal. The cost of building the new church was $30,000. (Courtesy R. Thornton Smith.)

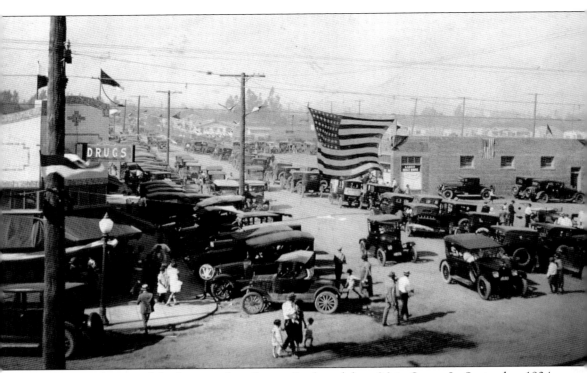

This is a photograph looking north at Sunset Boulevard from Main Street. In September 1924, the Temple Chamber of Commerce sponsored a free event to celebrate the first anniversary of the founding of the town of Temple and encourage more people to move to the new town. (Courtesy R. Thornton Smith.)

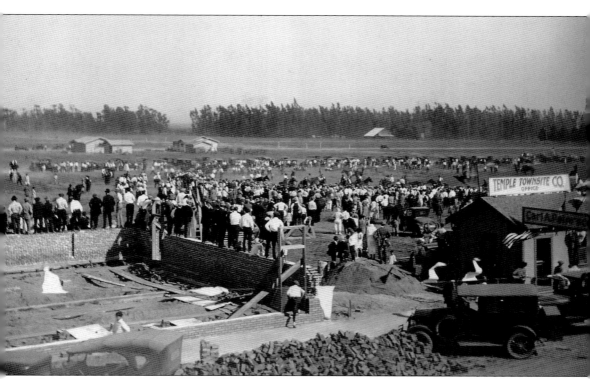

The first anniversary event occurred in vacant lots around the business center of the town of Temple. The event included horse races, a barbecue, and a "Grand Celebration." Music was provided by the Pacific Electric Band, and people came by automobile and streetcar to see what the new town had to offer. (Courtesy R. Thornton Smith.)

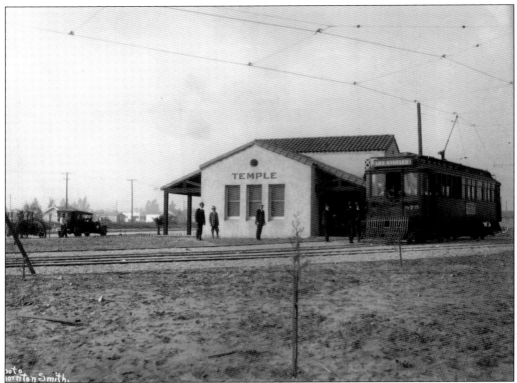

Walter P. Temple convinced the Pacific Electric Railway Company to extend its San Gabriel line to the new town of Temple. The line was completed in 1924 and terminated at Temple Park, where it turned around and went back to Los Angeles. The station for the line was located where the city hall for Temple City currently resides. (Courtesy R. Thornton Smith.)

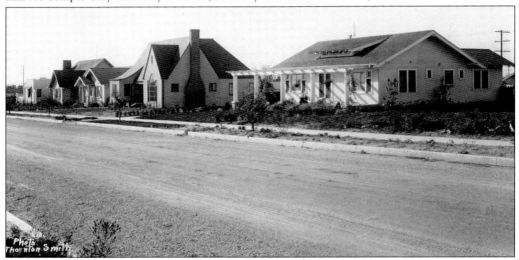

The house in the foreground was a model home located on Cloverly Avenue between Main Street and Workman Avenue. Around 1967, when a Ralphs Grocery store was being built on Las Tunas Drive (formerly Main Street), the home was moved down the street to the corner and is still there today. (Courtesy R. Thornton Smith.)

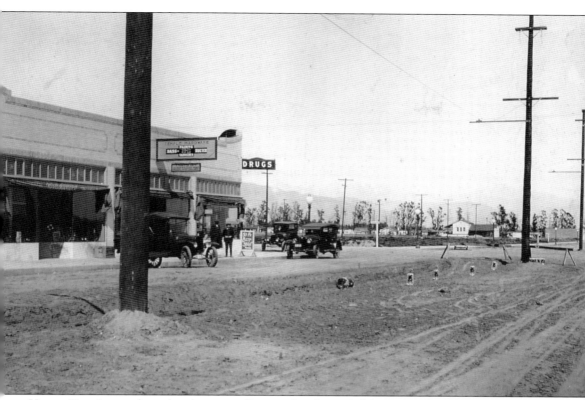

Henry Huntington brought electric trolleys to Southern California in the early 1900s. The extension to the town of Temple came just before red cars became an unprofitable mode of transportation. By 1941, the line to Temple City had been abandoned, and tracks were removed soon afterward. (Courtesy R. Thornton Smith.)

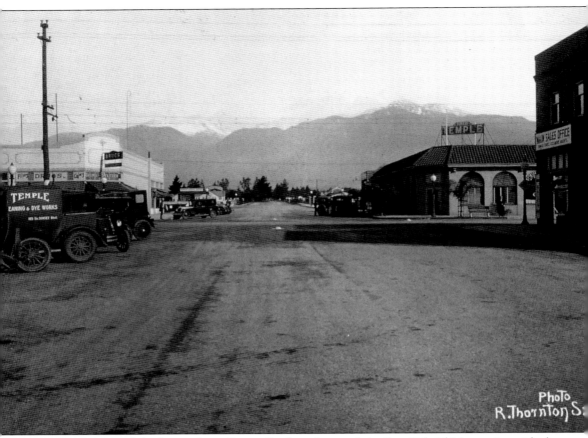

This photograph looks north on Sunset Boulevard toward the San Gabriel Mountains with the intersection of Main Street in the center. The building with the "Temple" sign on the roof is Temple National Bank. The two-story building on the right housed the offices of the real estate agents charged with selling lots for the town of Temple. (Courtesy R. Thornton Smith.)

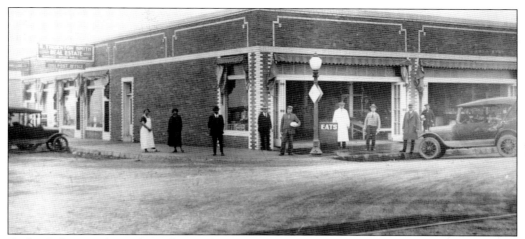

Cash Market was located on the southwest corner of Main Street and Sunset Boulevard. This photograph shows how the front of the market could open to the sidewalk. To the left of the market is the office of realtor R. Thornton Smith. Smith was also an insurance agent, notary, loan officer, and, for a time, the postmaster of the town. (Courtesy R. Thornton Smith.)

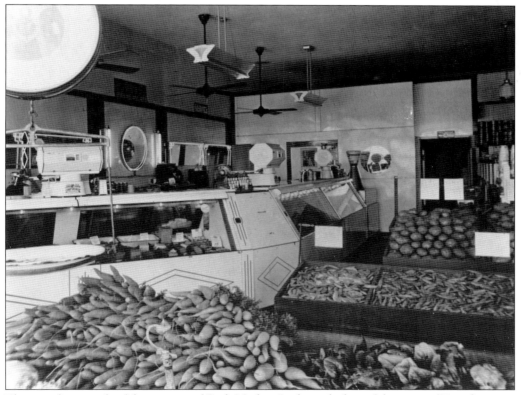

This is a photograph of the interior of Cash Market. In the early days of the town of Temple, it was the only business selling provisions. The open-air market sold prepared meals, had a meat counter, and carried fruits and vegetables to provide residents of the town with easy access to food staples. (Courtesy R. Thornton Smith.)

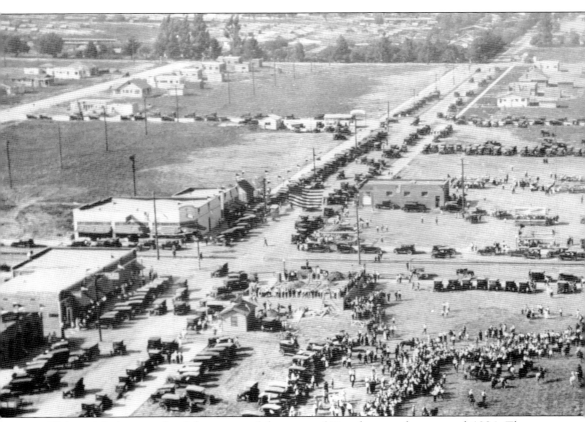

This aerial photograph of the center of the town of Temple was taken around 1924. The street running from top to bottom is Sunset Boulevard and the cross street is Main Street. At the top of the photograph, Sunset Boulevard narrows at Garibaldi Avenue. Sunset Boulevard remained narrow north of Garibaldi Avenue until it was widened in the 1960s.

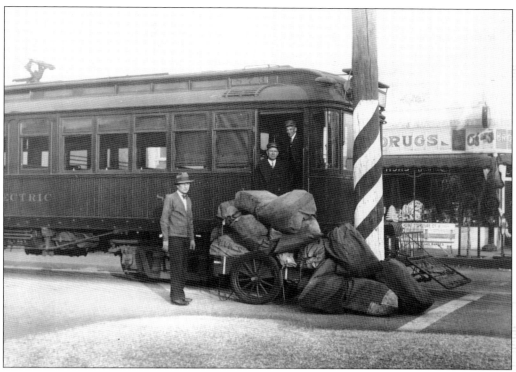

The extension of the Pacific Electric Red Car line to the town of Temple provided regular mail delivery to the residents. The first postmaster was housed for a short time in the Temple Pharmacy building. This is a photograph commemorating the first delivery of mail to the town by a streetcar. (Courtesy R. Thornton Smith.)

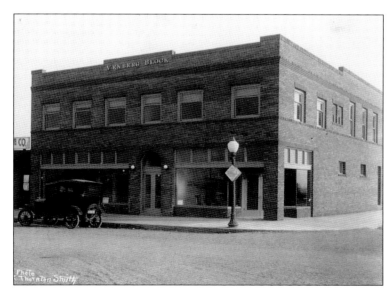

The Venberg Block was in the center of town at the southeast corner of Sunset Boulevard and Main Street. In the early days, many community organizations, including the Woman's Club, Temple Chamber of Commerce, and Masons, met in the upstairs rooms. The downstairs housed offices for the realtors selling lots in the town of Temple. (Courtesy R. Thornton Smith.)

The American Legion has a long history in the town of Temple serving war veterans and promoting patriotism. In 1926, it hosted an armistice event at Temple Park that featured Mabel Walker Willebrandt as the guest speaker. Temple City American Legion Post 279 is still in existence today. (Courtesy R. Thornton Smith.)

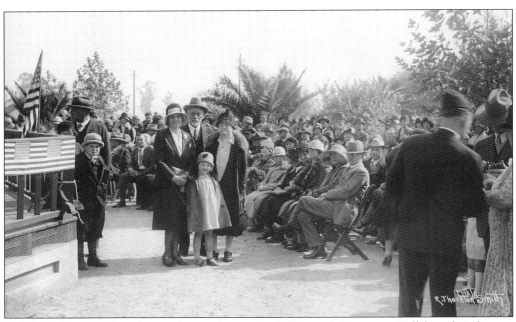

Mabel Walker Willebrandt was the speaker at the 1926 armistice event. Willebrandt is known as the "First Lady of Law" because she served as a US assistant attorney general from 1921 to 1929. She headed the division responsible for enforcing Prohibition. This is a photograph of Willebrandt with her daughter Dorothy Rae and her parents, Temple residents D.W. and Mabel Walker. (Courtesy R. Thornton Smith.)

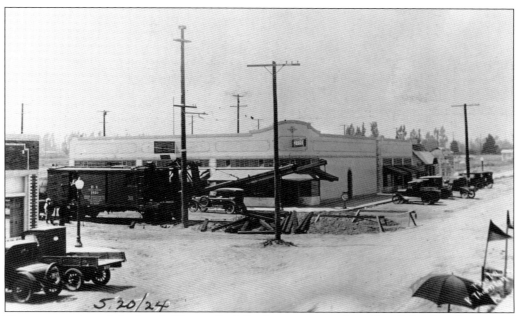

The construction of the Pacific Electric Red Car line extension from San Gabriel to the town of Temple was two blocks away from reaching the terminus of the line in May 1924 when this picture was taken. In this photograph, workers are laying rails at Sunset Boulevard before the paving of the street. (Courtesy R. Thornton Smith.)

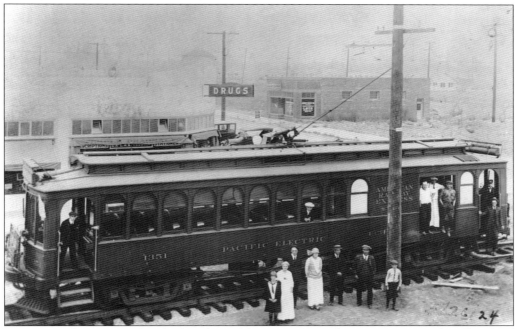

Approximately one year after the founding of the town of Temple, an extension of the Alhambra/San Gabriel line of the Pacific Electric Red Car line was completed, connecting the developing town to Los Angeles. The station for the town was located at the corner of Main Street and Kauffman Avenue. Pictured are the unidentified first riders of the new line. (Courtesy R. Thornton Smith.)

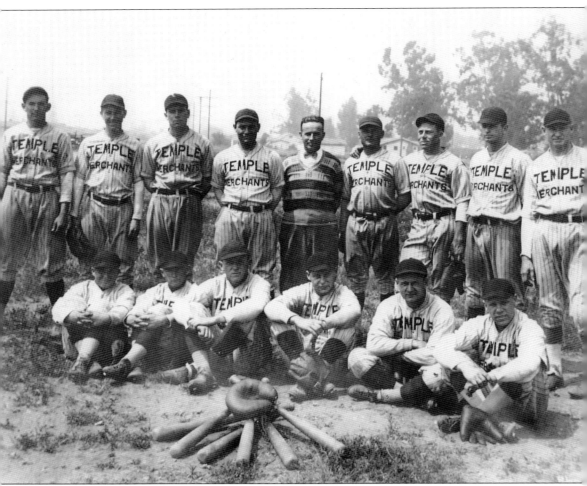

Baseball was a popular recreational activity in the town of Temple. There was a field on the southeast corner of Rowland Avenue and Main Street with covered bleachers and a snack bar where crowds regularly gathered to watch the local team, the Merchants, and other teams play. (Courtesy R. Thornton Smith.)

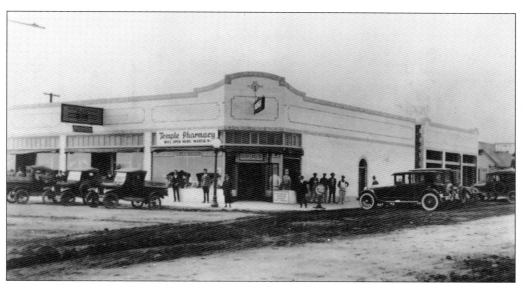

In March 1924, Temple Hardware and Temple Pharmacy were the first two businesses to open in the town of Temple. They set the stage for the development of a business district that could meet all the basic needs of residents. Although both businesses are gone, the building that housed them still exists. (Courtesy R. Thornton Smith.)

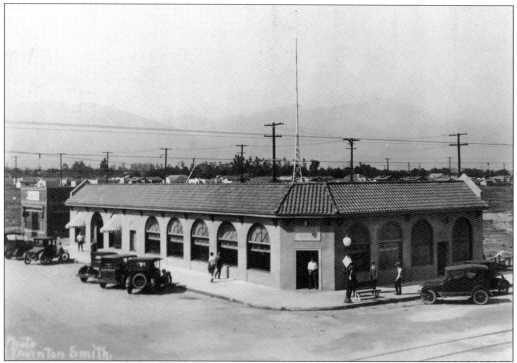

In the 1870s, Walter Temple's father and grandfather established the Temple and Workman National Bank in Los Angeles. Following in their footsteps, Walter Temple opened Temple National Bank on the northeast corner of Main Street and Sunset Boulevard. In addition to the bank, there was a café along the east end of the bank building. (Courtesy R. Thornton Smith.)

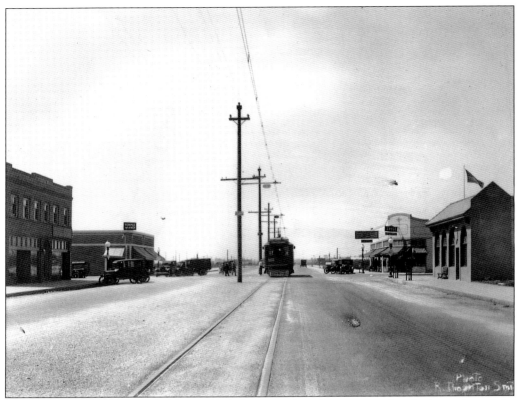

This photograph of the Pacific Electric Red Car was taken about a year after the inception of the route. The Venberg Building and Cash Market are on the left, and Temple National Bank and Temple Pharmacy are on the right. The intersection of Main Street and Sunset Boulevard was the heart of the town of Temple. (Courtesy R. Thornton Smith.)

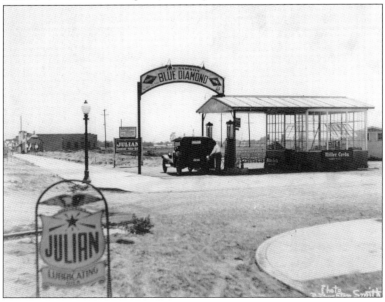

The H.T. Sampson gas station was located on the corner of Woodruff Avenue and Sunset Boulevard in the 1920s. The building to the right behind the gas station was restrooms. Years later, the site was the parking lot for an Alpha Beta Market. In the background on the left side is the Temple Pharmacy/Temple Hardware building. (Courtesy R. Thornton Smith.)

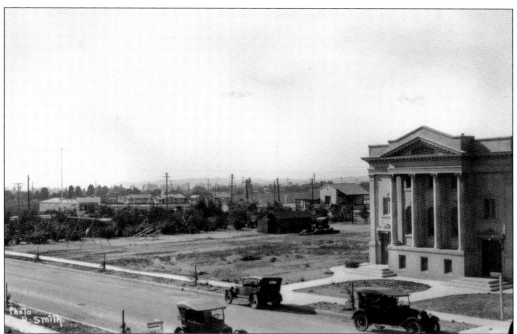

The town of Temple was a planned community with a park in the center of town. Adjacent to the park was a station for the Pacific Electric Red Car line. This photograph was taken from the corner of Woodruff and Golden West Avenues. In the foreground is Temple Community Church, and to the left are the park swings and teeter-totters for the kids. (Courtesy R. Thornton Smith.)

George Sears was the owner of Temple Hardware, the first business in town. Sears died in 1940, and his wife, Florence, sold the store in 1950. Florence Sears and her daughter Lura then moved to Pasadena to be closer to Lura's high school. At age 15, Lura was an aspiring opera singer with the San Gabriel Valley Opera Company. This is a photograph of Lura as a toddler at Temple Hardware.

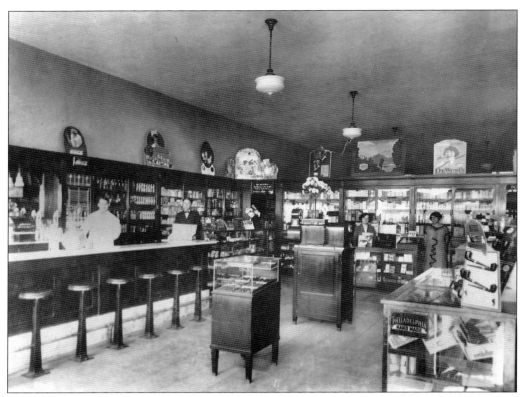

Temple Pharmacy not only sold medicinal and first aid supplies, but the drugstore also sold various sundries. For those customers who were hungry or thirsty, there was a lunch counter inside the store. Lunch counters were just becoming popular in 1924 and remained so until the advent of fast-food restaurants. (Courtesy R. Thornton Smith.)

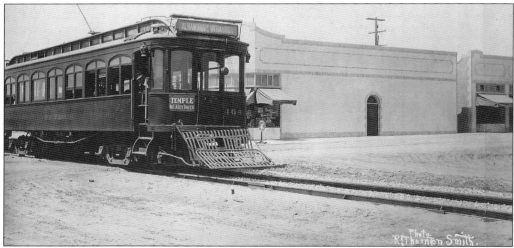

Walter Temple and his business partners recognized the value of a mass transit system for a developing community in the 1920s. Unfortunately, shortly after the founding of the town of Temple, streetcars started to give away to other modes of transportation such as cars and buses. (Courtesy R. Thornton Smith.)

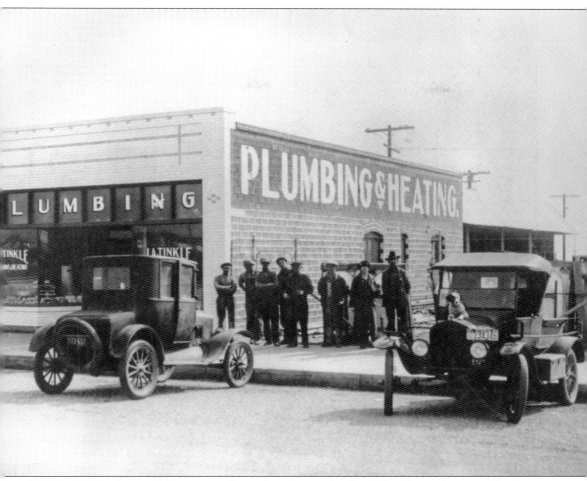

J.A. Tinkle Plumbing and Heating was located on the south side of Main Street, between Kauffman and Golden West Avenues (across the street from Temple Park). By 1925, the town of Temple offered most of the basic services that new residents needed. In this photograph, unidentified workers pose in front of the store while a dog poses on a nearby car. (Courtesy R. Thornton Smith.)

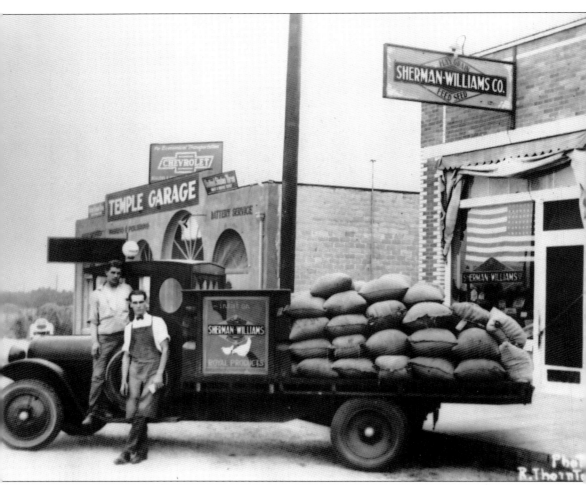

The town of Temple's local hay, grain, feed, and seed store was Sherman Williams, located on Sunset Boulevard, south of Main Street. In a town where residential lots were designed to be small farms or ranches, Sherman Williams was a valuable resource for residents. (Courtesy R. Thornton Smith.)

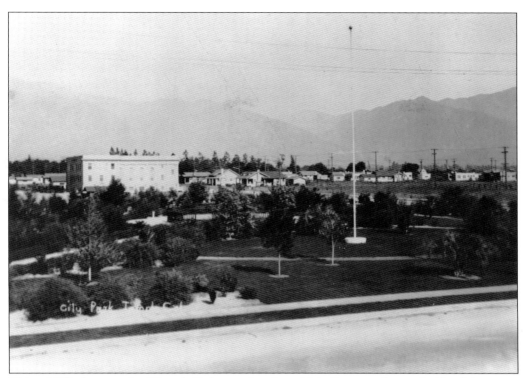

This c. 1930 photograph of Temple Park was taken from Main Street on the south side of the street. The trees and bushes have taken root, sidewalks and curbs have been installed, and the Temple Community Church, Methodist Episcopal building can be seen north of the park. (Courtesy R. Thornton Smith.)

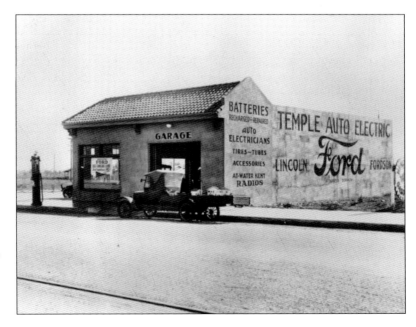

After he sold his 3,000 chickens and ranch located on Baldwin and Olive Avenues in the town of Temple, Vic Torrance opened Temple Auto Electric. He bought the Ford parked in front of his store in El Monte for $325. During the depression, Torrance would attract customers to his store by raffling off a battery charge. (Courtesy R. Thornton Smith.)

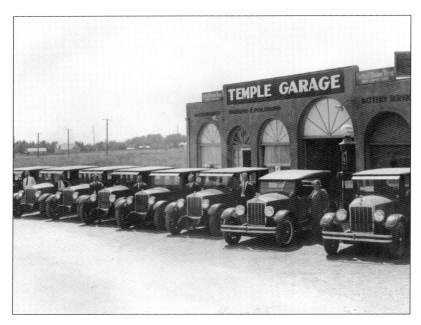

Temple Garage was located on the west side of Sunset Boulevard, south of Main Street. Car owners could take their cars to the garage to have their batteries serviced, get new tires, or buy accessories. They also could get gasoline and have their car washed and polished. (Courtesy R. Thornton Smith.)

The Temple Red Car station was located east of the town's business district and adjacent to Temple Park. Streetcars coming from Los Angeles through Alhambra and San Gabriel would turn around at the station and return to downtown. Today, city hall is located where the station once stood. (Courtesy R. Thornton Smith.)

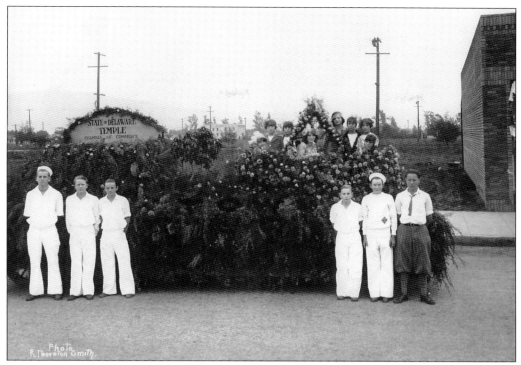

In 1928, the Temple Chamber of Commerce entered a float in the Pasadena Tournament of Roses Parade. The description in the official program says, "Another of the small communities, Temple, showed peaches from Delaware by way of South Santa Anita School—large baskets of them in heather and rose settings. The harmonica band from the school showed that the community also could supply its own music." (Courtesy R. Thornton Smith.)

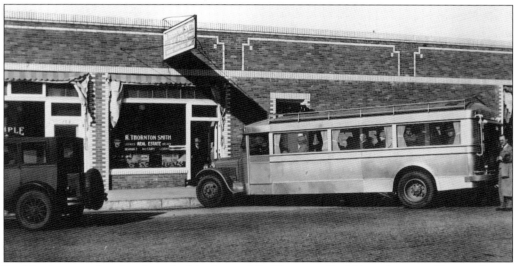

In this photograph, a bus is parked in front of R. Thornton Smith's real estate office on Sunset Boulevard. In the 1920s, motorized buses began to replace the horse-drawn omnibuses of the past and were frequently used to provide transportation beyond the termini of a streetcar line. (Courtesy R. Thornton Smith.)

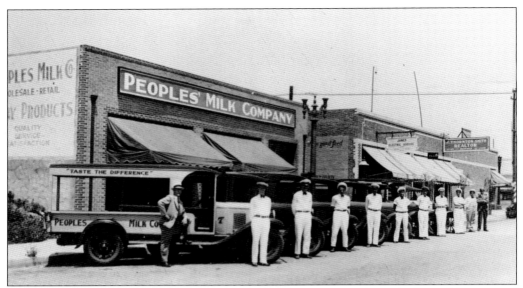

The People's Milk Company was one of many new businesses in the early days of the town of Temple. The company delivered fresh milk in glass bottles to local homes. The bottles of milk would be placed in an insulated box on the porch or in a cubby built into the side of the house. (Courtesy R. Thornton Smith.)

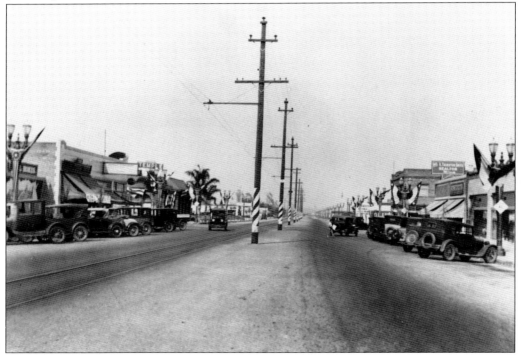

This is a view of Main Street looking east in the 1930s. To the left is Temple Pharmacy and Temple National Bank. On the right are the offices of R. Thornton Smith. As a realtor, Smith took most of the early photographs of the town of Temple. His photographs are the main source of visual records for the town. (Courtesy R. Thornton Smith.)

Three

FIRST 50 YEARS

Shortly after the founding of the town of Temple, the town faced challenges to its future viability. In 1925, the California Legislature passed the Mattoon Act. The act was envisioned to provide funding for public works improvements, but the unintentional consequence was that property owners were burdened with assessments that discouraged new sales and increased foreclosures. The act was eventually repealed in 1933, but it took years for Temple City to recover. In 1939, the Temple City Chamber of Commerce organized an event, the Jubilee of Progress, to celebrate the growth of the community. The jubilee included a parade, a pet show, a flower show, and a nighttime burning of the paid-off public improvement bonds from the Mattoon Act.

Temple City attracted families that were community-minded and eager to ensure that their city was a desirable place to raise a family. The Temple Chamber of Commerce was founded in 1924, followed by the Woman's Club in 1925, and the American Legion Post 279. As the city grew, so did participation in service clubs. The Kiwanis Club was established in 1939, followed by the Lions Club in 1944. Many other volunteer organizations were active in Temple City during the first 50 years of the town, and participation in youth organizations also flourished. There were numerous Boy Scouts, Girl Scouts, and Camp Fire Girl troops in Temple City. The Girl Scouts even had its own clubhouse on land purchased through community fundraisers. The Temple City YMCA sponsored several youth groups, and Little League Baseball had so many participants that two leagues were formed. In the 1960s, the Sister Cities Association was established, and the Miss Temple City program commenced.

The residents of Temple City voted to incorporate in 1960, in part to avoid being annexed by neighboring cities. Merrill Fitzjohn, the founder and original owner of Fitzjohn Jewelers on Las Tunas Drive, was appointed as the city's first mayor. In the years since Walter Temple founded the town of Temple, Temple City went from a rural area with no businesses and very few homes to a full-service, family-friendly, self-governing city.

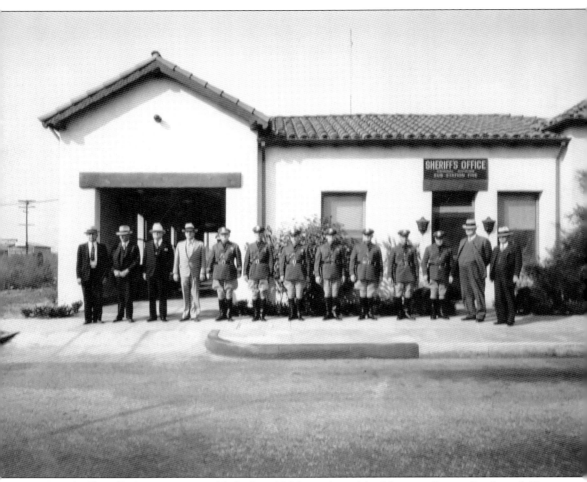

Temple Sheriff's Station was established in 1926 in a leased building on Sunset Boulevard. Two years later, it was moved to a former gas station on Main Street. In 1930, a new Temple Sheriff's Station, shown in this picture, was built on the corner of Main Street and Cloverly Avenue. Temple Sheriff's Station remained in this building until 1939. (Courtesy R. Thornton Smith.)

Temple Sheriff's Station moved to what is now the 5800 block of Temple City Boulevard in 1939. During World War II, this station also served as a civil defense command post. In the mid-1950s, the station became too small, as personnel and services increased. Temple Sheriff's Station moved to its current location on Las Tunas Drive in 1956.

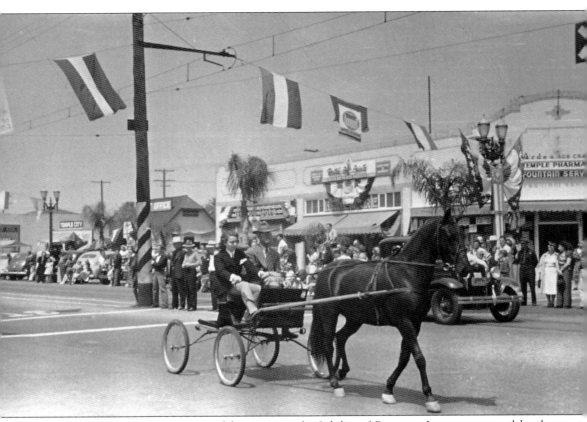

Temple City's first community celebration was the Jubilee of Progress. It was sponsored by the Temple City Chamber of Commerce and held for three years beginning in 1939. The multiday event celebrated the growth of Temple City during its first 15 years. Activities included a flower show and a parade down Las Tunas Drive with horses and marching units.

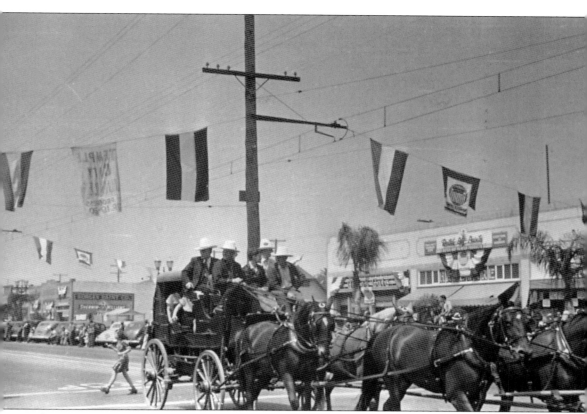

The predecessor to the Camellia Festival was the Jubilee of Progress. It was held in 1939, 1940, and 1941 with the support of local businesses. The event ended with the commencement of World War II. It was not until 1944 that a new community celebration, the Camellia Festival, was established by the Woman's Club.

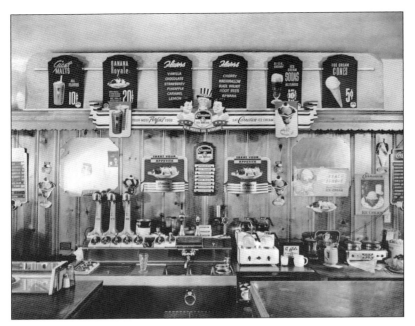

Before it was Earl's Grill, it was Earl's Malt Shop. Located on the corner of Primrose Avenue and Las Tunas Drive, Earl's opened in 1940 with a soda fountain and lunch counter. This picture was featured in the *Temple City Times* on the one-year anniversary of the restaurant. Earl's served Temple City residents for over four decades.

Los Angeles County Fire Station No. 47 opened on Kauffman Avenue in December 1948. It was constructed next to the Woman's Club building, which now houses the Historical Society of Temple City Museum. This c. 1960 photograph was taken in front of station No. 47.

The Temple City Lions Club was sponsored by the San Gabriel Lions Club in 1944. This photograph shows the first 13 presidents of the club. The club was active in the community for over 40 years. Its service projects focused on collecting and recycling eyeglasses for the visually impaired and participating in International White Cane Day.

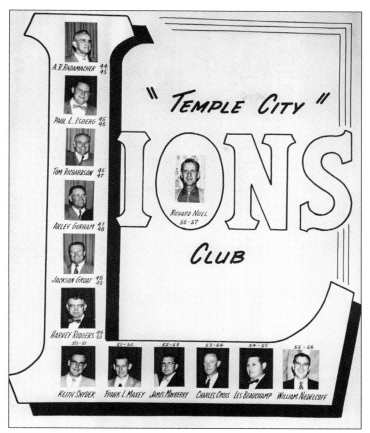

Ward Kimball was not just an artist and musician, he was also a railroad aficionado. Here is an undated photograph of Kimball in his backyard on Ardendale Avenue. Kimball was an animator for Disney and is credited with inspiring Disney to have a railroad at Disneyland. As a tribute to Kimball, Disneyland Railroad engine No. 5 is named Ward Kimball.

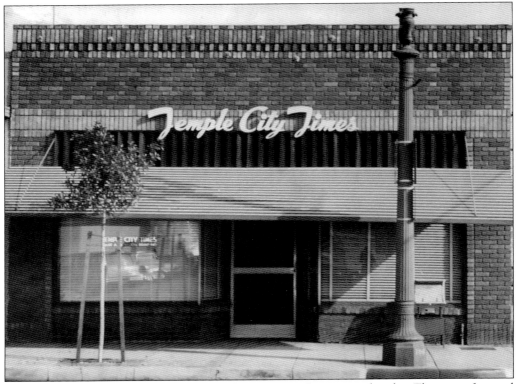

The *Temple City Times* produced a semiweekly newspaper for over six decades. The paper featured local news and community events. The building in this picture housed the *Temple City Times* for many years and was one of the first structures constructed in the town of Temple. It was located on the west side of Sunset Boulevard, south of Las Tunas Drive.

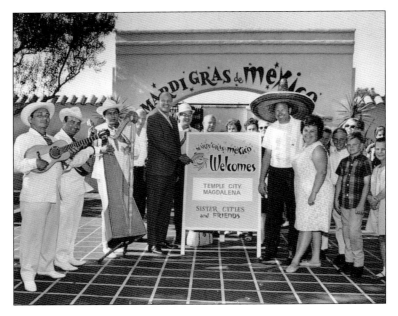

Beginning in 1964, the Temple City Sister Cities Association had a relationship with Magdalena de Kino, Mexico. This photograph was taken in 1968 during a visit to Temple City. Since 1984, Temple City has also established a Sister Cities relationship with Hawkesbury, Australia. Today, Temple City Sister Cities coordinates annual youth exchanges with Hawkesbury.

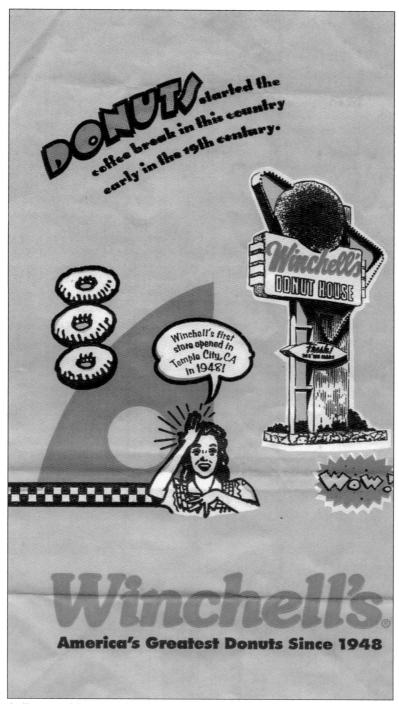

Verne Winchell opened his first donut house in Temple City on October 8, 1948. At its peak, there were over 1,000 Winchell's Donut Houses. In 1968, Winchell's merged with Denny's Incorporated, and Verne Winchell became the chief executive officer of Denny's until he retired in 1980. Winchell was also known for being a successful racehorse breeder.

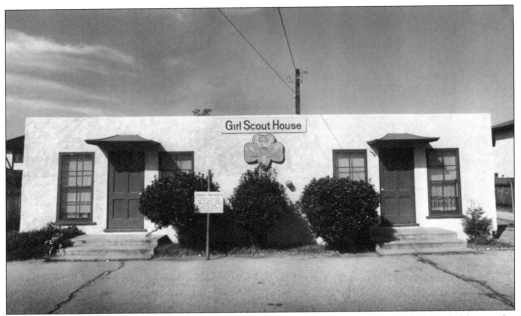

In 1948, the Temple City community raised money to purchase the land and build a clubhouse for all the Girl Scout troops in the city. The building stood at 9509 Longden Avenue (across the street from Longden Avenue School) until 1983, when the Sierra Madre Girl Scout Council sold the property, and the structure was demolished much to the dismay of the Temple City community.

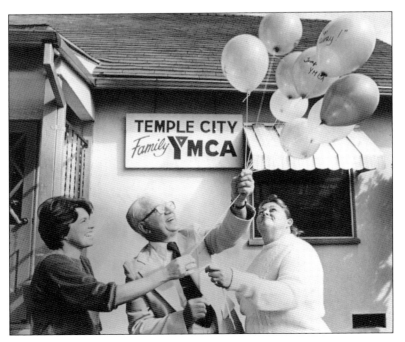

Temple City Family YMCA was located at 5926 Rowland Avenue in a residential neighborhood with a backyard pool. The facility offered after-school and summer programs for youth, along with swimming lessons and family activities. This picture features, from left to right, Elaine Mushinskie, Ray Hatch, and program director Maxine Nordin in the 1960s.

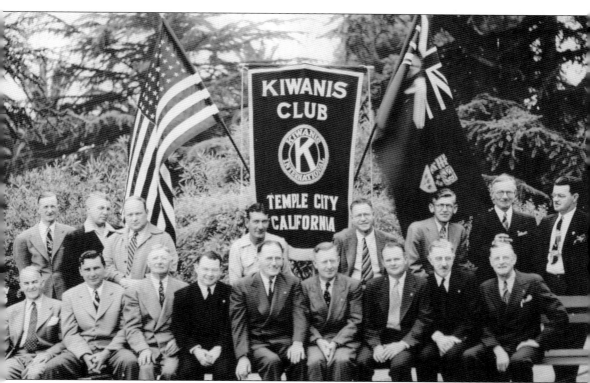

Since the founding of the town, dedicated volunteers have added much to the community. The Kiwanis Club of Temple City was founded in 1939 and is still active in the community today. This photograph, taken in 1948, features future mayor Al Nunamaker (second row, third from left) and Temple City schools music director Phil Memoli (first row, third from left).

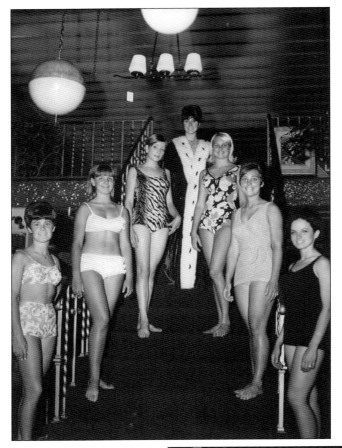

The Temple City Chamber of Commerce began conducting the Miss Temple City pageant in 1966. One queen was chosen to represent the community at various activities. The contestants competed in swimsuits, formal wear, and a talent contest. Pictured are the contestants who participated in the second year of the beauty pageant, along with the 1967–1968 queen Kathy Tiberti (top, center).

The Woman's Club of Temple City had its first meeting in 1925. In 1931, the club purchased a lot on the corner of Kauffman and Woodruff Avenues for a clubhouse. By 1948, the building was completed and paid for in full. Initially, the clubhouse doubled as Temple City's library. In this photograph, unidentified members are celebrating the 43rd anniversary of the club. (Courtesy Woman's Club of Temple City.)

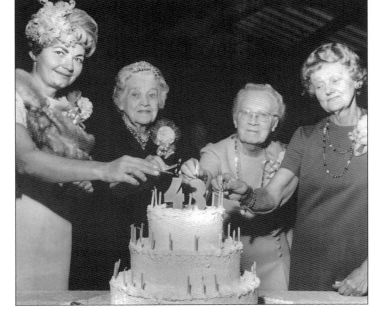

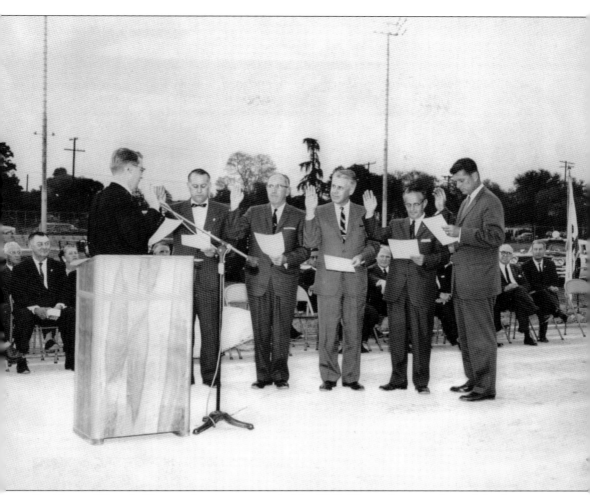

Residents of Temple City voted to incorporate in May 1960. Pictured are members of the first city council being sworn in at Temple City High School. From left to right are Lou Merritt, T. Donald Buchan, Howard Dickason, Merrill Fitzjohn, and Jack R. Tyrell. Fitzjohn served as the first mayor of Temple City.

Since the founding of the town of Temple, service organizations have worked to make the community a better place to live. These c. 1950 city welcome signs featured the logos of Temple City's service organizations, including Kiwanis, Rotary, Lions, Quota, Woman's Club, Jaycees, Toastmasters, and others. Temple City residents George and Pat Hanft designed the signs.

The Temple Chamber of Commerce was established less than a year after the founding of the town of Temple and became the Temple City Chamber of Commerce after the town of Temple changed its name in 1928. The goal of the chamber was to encourage new businesses to locate in town and to promote the interests of existing businesses. In the early years, the members of the chamber met upstairs in the Venberg building on the southeast corner of Main Street and Sunset Boulevard.

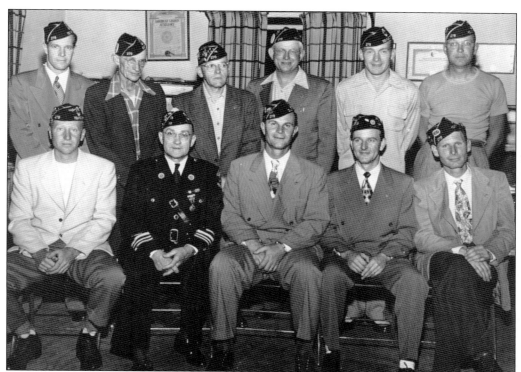

Temple City American Legion Post 279 was formed in the early years of the town of Temple. The post was named in honor of Joseph L. Kauffman, younger brother of Temple's business manager Milton Kauffman. The younger Kauffman was killed in World War I at the Battle of Argonne at age 22. Pictured are the 1949 officers of American Legion Post 279.

In 1919, Walter Temple and his sons dedicated this memorial to Sgt. Joseph Kauffman, brother of Milton Kauffman. The memorial was reported to be the first individual monument on the Pacific coast to be erected for a World War I fallen hero. Originally located on Temple's property in Montebello, it was moved to Temple City Park in 1930.

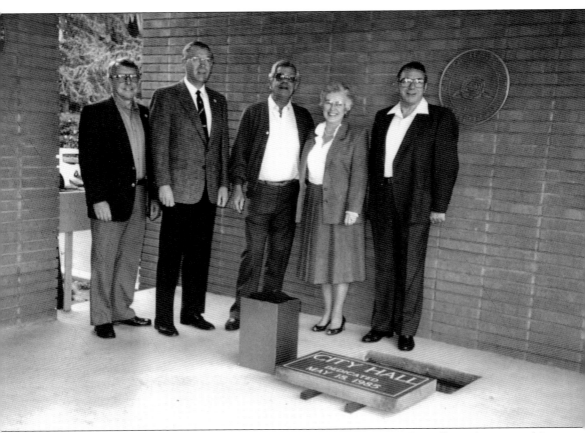

In 1985, Temple City moved into its new city hall on the corner of Kauffman Avenue and Las Tunas Drive. The building was previously occupied by the Los Angeles County Department of Engineering and constructed on the site of the old Pacific Electric Red Car station. Standing next to a time capsule marker are, from left to right, city manager Karl Koski and councilmembers Bill Dennis, Tom Atkins, Mary Lou Swain, and Ken Gillanders.

Four
TEMPLE CITY SCHOOLS

Palo Solo School was located in the northern section of Rancho San Francisquito and established in 1908. It was initially a two-room wooden schoolhouse for 24 students, grades first through twelfth. By 1911, Palo Solo's population had grown to 126 students, and the school's name was changed to South Santa Anita School. Ten years passed, and South Santa Anita School became a grammar school, with high school students being sent to Pasadena. By 1944, the school had so many students that seventh and eighth graders were also sent to Pasadena. South Santa Anita School changed its name to Longden Avenue School in 1946.

To manage the ever-growing population in Temple City, Cloverly School opened in the southern section of the town in 1947. In 1950, a third elementary school, Emperor School, opened to serve children who lived on the west side of Rosemead Boulevard. Also that year, the Pasadena School District opened Temple City Junior High School on Oak Avenue. One year later, Temple City started a program for visually impaired students in the San Gabriel Valley. La Rosa School opened in 1955 and was the final elementary school to be built in Temple City.

In 1954, the voters approved the unification of the school district, and the campus on Oak Avenue became Temple City High School. Construction began on a new high school to be located on the corner of Lemon Avenue and Temple City Boulevard. Beginning with the 1956–1957 school year, high school students attended classes at the new campus. The temporary high school campus then reverted to a junior high school with a new name, Oak Avenue School.

Since its humble start in 1908, Temple City's schools have produced many notable graduates, including astronaut Steve Lindsey, physicist/astronomer Kent Cullers, 1950s pop singer Dodie Stevens, World Cup soccer player Jimmy Conrad, women's professional soccer player Erin Martin, Superior Court judge Rolf Treu, and children's book author/illustrator LeUyen Pham. Temple City's schools are considered some of the top schools in Los Angeles County.

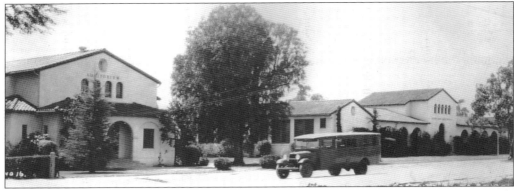

For almost 40 years, South Santa Anita School was the only school serving the children in Temple City. The school originally served first through twelfth graders but eventually became an elementary school. The name of the school was derived from the school's proximity to the southern boundary of Rancho Santa Anita.

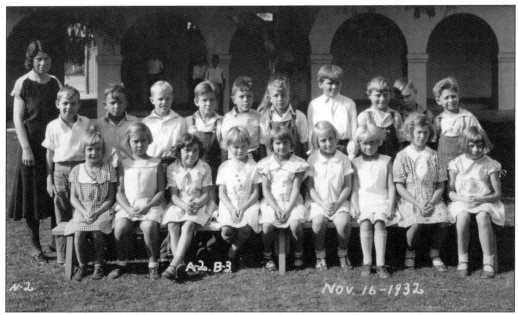

This is a second-grade class photograph taken in front of South Santa Anita School in 1932. South Santa Anita School originally served elementary and secondary students, but by the time this photograph was taken, it was a kindergarten through eighth-grade school with over 300 students. (Courtesy Temple City Unified School District.)

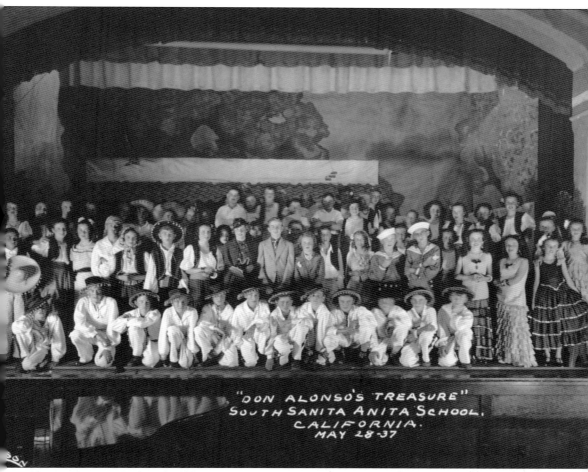

The performing arts have long been an integral part of education in Temple City's schools. In the late 1920s, an auditorium was built at South Santa Anita School to accommodate performances such as Don Alonso's *Treasure*. The auditorium is still in use and is the last remaining early California-style building on the campus. (Courtesy Temple City Unified School District.)

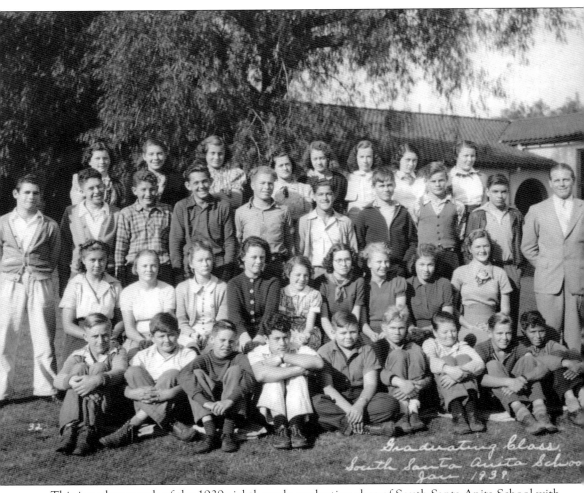

This is a photograph of the 1939 eighth-grade graduating class of South Santa Anita School with their teacher, Harold McMasters. At the time, the school had about 500 students in kindergarten through eighth grade. The graduating students continued their education in the Pasadena Unified School District. (Courtesy Temple City Unified School District.)

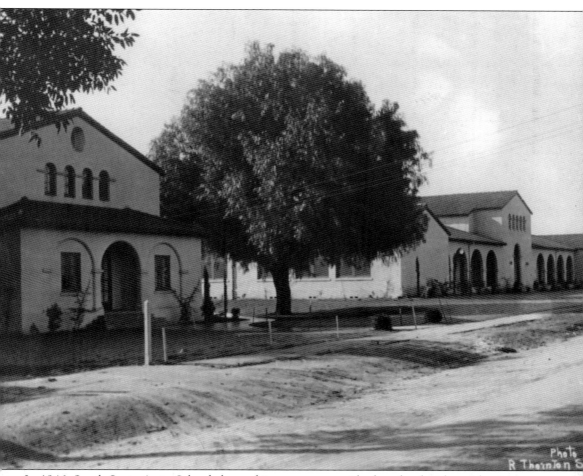

In 1946, South Santa Anita School changed its name to provide the school with an identity not tied to Arcadia. Because the school faced Longden Avenue, its name was changed to Longden Avenue School. Contrary to widespread belief, the street was not named for jockey Johnny Longden, but for Orray W. Longden, a prominent local citizen who had served as a Los Angeles County supervisor. (Courtesy R. Thornton Smith.)

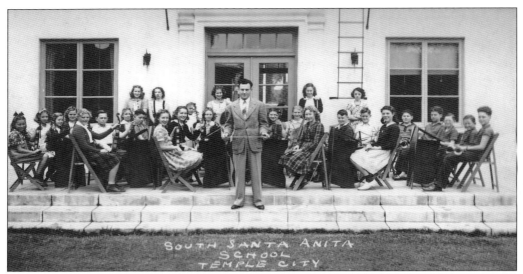

Even though it was a grammar school, South Santa Anita School had both an orchestra and a marching band. This photograph, taken in 1940, is of orchestra students practicing on the steps of one of the school buildings. The marching band represented the school in parades throughout Southern California. (Courtesy Temple City Unified School District.)

This is a photograph of eighth-grade graduates of South Santa Anita School. During the time that the school was in the South Santa Anita School District (1911–1949), the State of California eighth-grade diplomas were issued by the Los Angeles County Board of Education and not the local school district. (Courtesy Temple City Unified School District.)

Each year, Temple City Council Parent Teacher Association (PTA) holds a Founders Day event to recognize past and present PTA volunteers. In 1946, PTA members from South Santa Anita School performed a skit to recognize the founders of the organization. South Santa Anita School PTA held its first meeting in 1921. (Courtesy Temple City Unified School District.)

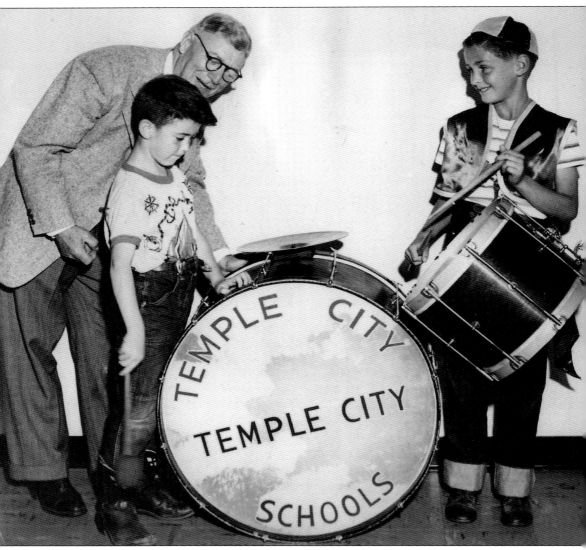

Philip Memoli was the music director for Temple City schools. He wrote the "Temple City Camellia Emblem March" before retiring in 1950. In 1958, the auditorium at Longden Avenue School was named in his honor posthumously. In this photograph, he is posing with two students for a publicity picture. (Courtesy Temple City Unified School District.)

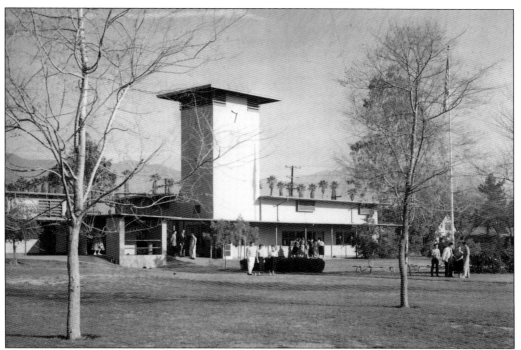

Temple City Junior High School was built in 1950 by the Pasadena Unified School District. When the Temple City School District voted to unify in 1954, the school was annexed by Temple City Unified. It was used as Temple City High School while a new campus on Lemon Avenue and Temple City Boulevard was being built. (Courtesy Temple City Unified School District.)

Cloverly School was the first school to be built after the establishment of the town of Temple. As the second school in Temple City, it opened in 1947 to relieve Longden Avenue School from having to offer double sessions. In 1961, Cloverly became a fourth-grade through sixth-grade school. (Courtesy Temple City Unified School District.)

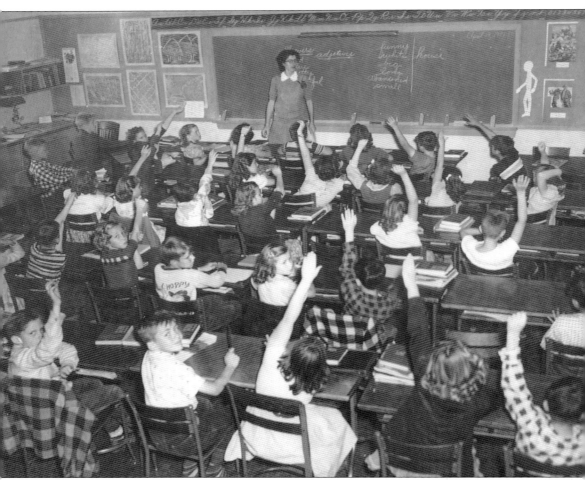

This is a photograph of elementary schoolteacher Georgia Bunker's class in 1951. Bunker taught in a crowded fourth-grade classroom at Cloverly School at a time when enrollment was increasing faster than classrooms could be built. During the 1951 school year, a cafeteria was built at Cloverly School for the growing school population. (Courtesy Temple City Unified School District.)

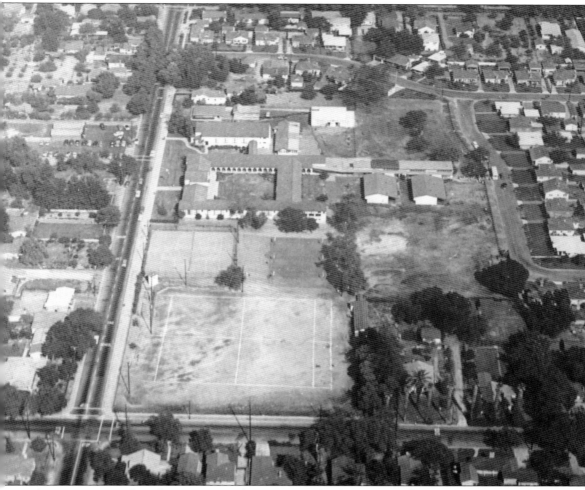

The vacant corner lot adjacent to Longden Avenue School was originally owned by the Temple City Community Youth Center Committee. It purchased the land with the intention of building a community swimming pool. Instead, the group sold the land to the school district and donated the proceeds to help build a swimming pool at Temple City High School. Later, the land became a baseball field for Little League.

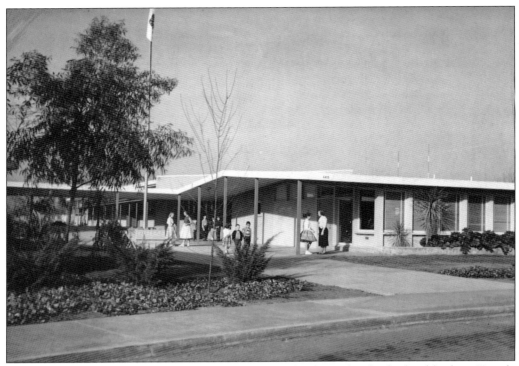

Originally referred to as Muscatel School, Emperor School was the third school built in Temple City. When it was built in 1950, it had a kindergarten room and eight classrooms and was one of the most modern schools in Los Angeles County. The site for Emperor School was chosen so that students would not have to cross busy Rosemead Boulevard going to and from school. (Courtesy Temple City Unified School District.)

Temple City schools began offering a program for visually impaired students in 1951. The program served students from the 26 school districts in the San Gabriel Valley. With assistance from the Lions Club White Cane program, in 1954 the program was declared one of the best equipped by the American Foundation of the Blind. (Courtesy Temple City Photos.)

The Temple City Parent Teacher Association (PTA) has been an important partner with Temple City schools since it was established at South Santa Anita School in 1921. They have raised money and provided volunteers to support activities at all Temple City school sites. This is a photograph of some performers in a PTA fundraising event held in 1956.

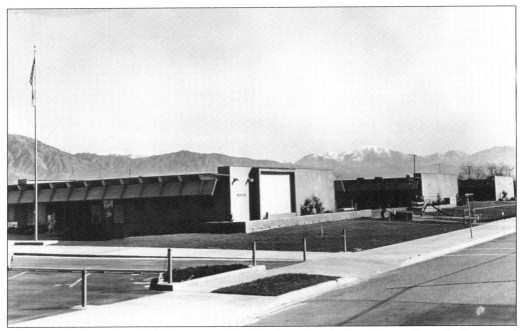

La Rosa School was the final elementary school built in Temple City. Originally in the Rosemead School District, it was annexed by Temple City when the district unified. It opened in 1955 as a kindergarten through sixth-grade school. In 1961, it became a kindergarten through third-grade school. (Courtesy Temple City Unified School District.)

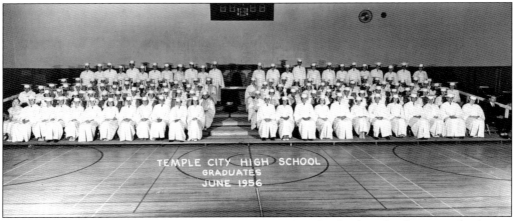

The fall of 1954 was the first year of Temple City High School. The school was on the former Temple City Junior High School campus, and the student body was made up of eighth through eleventh graders. The class of 1956 was the first senior class at Temple City High School, and their graduation took place in the gymnasium.

When looking for land where a high school could be built, a 10-acre site owned by the California Institute of Technology that was being used for experimental farming was chosen. The land came with a two-story building that was located on Temple City Boulevard. In the first several years of Temple City High School, the building was used for science classes.

The house in the photograph was located on the property purchased from the California Institute of Technology by the Temple City Unified School District for the new Temple City High School. The house was used as a faculty retreat until it was torn down to make room for the construction of additional classrooms.

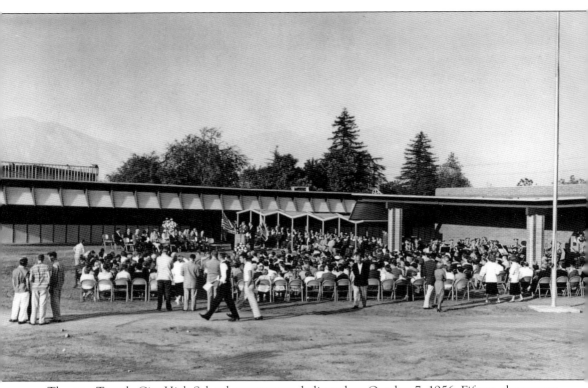

The new Temple City High School campus was dedicated on October 7, 1956. Fifteen classrooms were available for use. Until the high school campus construction was fully completed, some classes continued to be held at the newly named Oak Avenue School, and the students walked back and forth between the two campuses.

In 1963, the student population at Temple City High School was growing faster than classrooms could be constructed. The tents in this photograph were put up on campus to create more classrooms until permanent ones could be built. The temporary structures were cold in the winter and hot in the summer.

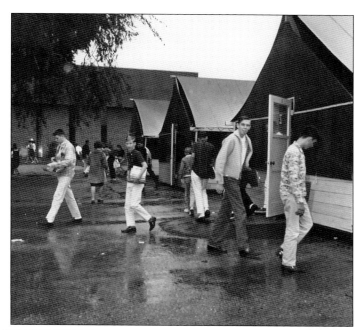

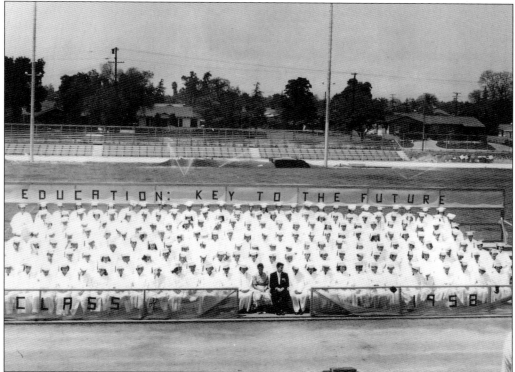

The 1958 Temple City High School's graduating class was the first class to have its graduation conducted on the football field of the new campus. Approximately 200 students graduated at the new facility. The grandstands and lighting had been completed in late 1957. The snack bar and ticket booth were completed in June 1958.

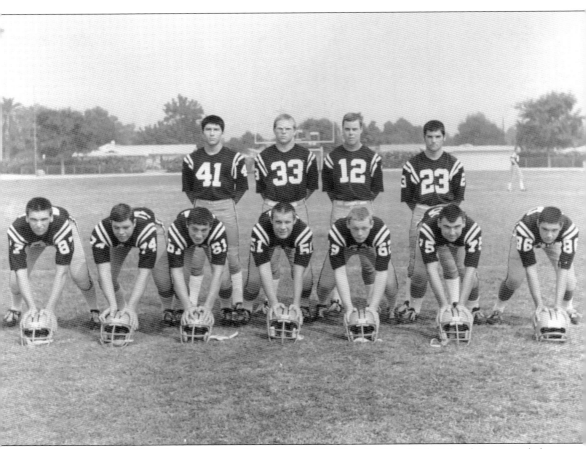

After four years of not losing a football game, in 1973, Temple City High School Rams tied the California State record for most consecutive wins. Even though the Rams lost the next game, they went on to win their fourth straight California Interscholastic Federation football championship. Pictured is the offensive team for the 1973 Rams. (Courtesy Temple City Unified School District.)

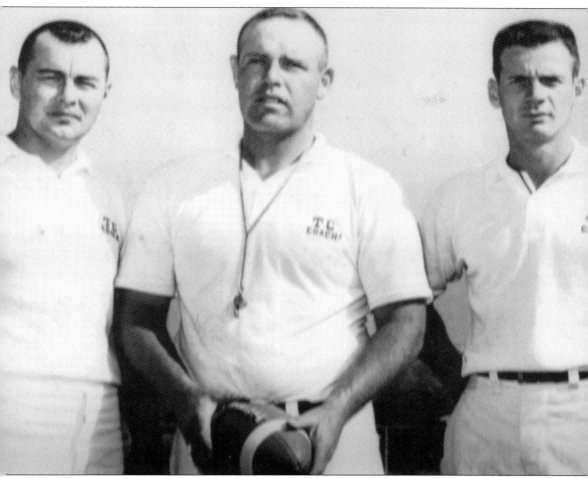

Bob Hitchcock (center), head football coach at Temple City High School, led the Rams to seven California Interscholastic Federation championships during the 1970s, and he was named California State Coach of the Year in 1972. Hitchcock, along with his longtime assistant coaches Ed Mohr (left) and Don Swanson (right), brought acclaim to Temple City's football program. In 2004, the high school football stadium was named Bob Hitchcock Stadium. (Courtesy Darryl Fish.)

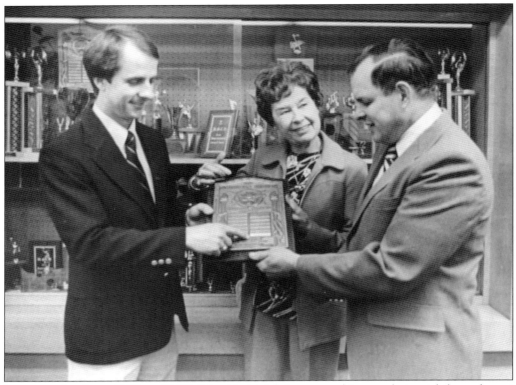

Just out of college, William "Bill" Schmidt (right) began teaching math to eighth graders at Longden Avenue School in 1955. He was one of the first blind teachers in California to teach sighted children. He went on to become a principal and administrator in Temple City. Schmidt is pictured with Jerry Childs and Mayne Utterson, holding an award plaque.

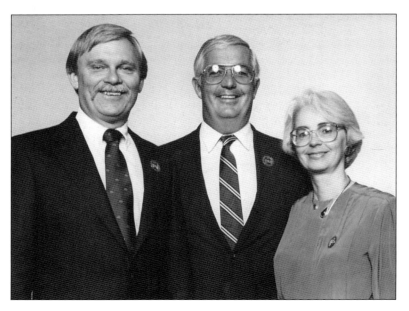

Although the Temple City Unified School District has had many excellent teachers, only one—English teacher Shirley Rosenkranz—has been selected California Teacher of the Year. In this photograph, taken in 1987, Rosenkranz is being honored by a principal from another school district and the president of Burger King Corporation.

Roger Lockie attended South Santa Anita School, where he was a student of Philip Memoli. He began teaching at Temple City High School in 1955 and spent 28 years in the district. Lockie started the Temple Belles, an all-girl singing group. Later, the group became coed and was renamed the Brighter Side Singers. For many years, Lockie produced the school's musicals, starting in 1965. (Courtesy Temple City Unified School District.)

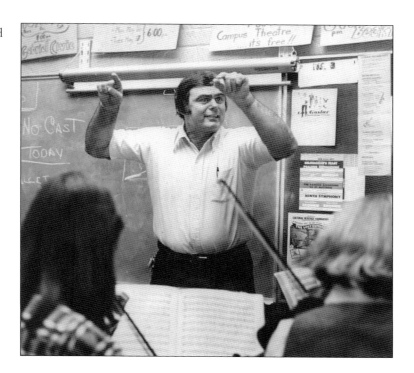

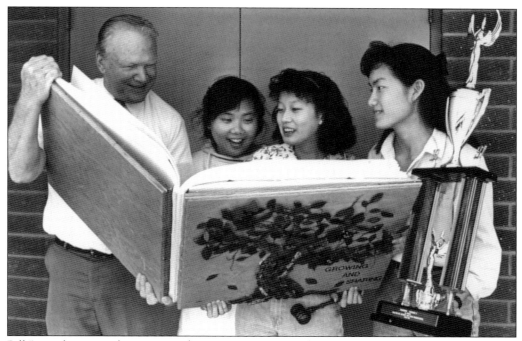

Bill Perini began teaching in Temple City in 1946. After three years of being a teacher, he became the principal at Emperor School. Perini worked for the district for 39 years, holding many different positions. In this photograph, he is reviewing a scrapbook with unidentified members of the Temple City High School Key Club.

To commemorate the 50th Super Bowl, the National Football League sent former Super Bowl players back to their high schools to present a "golden football." Kent Kramer played tight end for the Temple City High School Rams, graduating in 1962. He attended the University of Minnesota and spent eight years playing professional football. Kramer participated in Super Bowl IV with the Minnesota Vikings. (Courtesy Temple City Photos.)

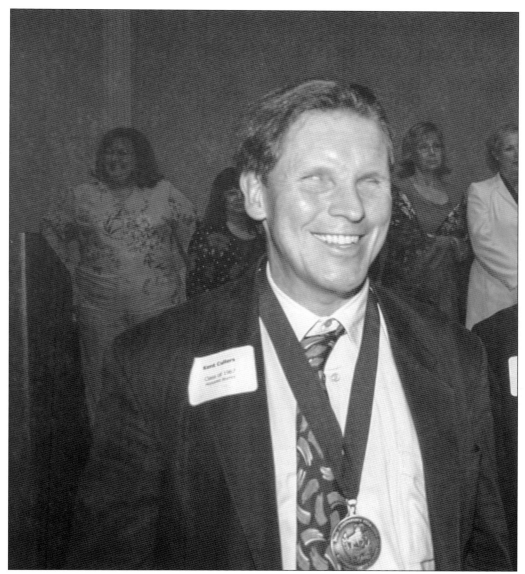

In 1967, Kent Cullers was the valedictorian at Temple City High School. Blind since birth, he earned a doctorate in physics from the University of California, Berkeley. He is the world's first blind physicist and is believed to be the first blind-since-birth astronomer. Dr. Cullers worked for NASA's Search for Extraterrestrial Intelligence. He was portrayed as the fictional character Kent Clark in the movie *Contact*. (Courtesy Temple City Photos.)

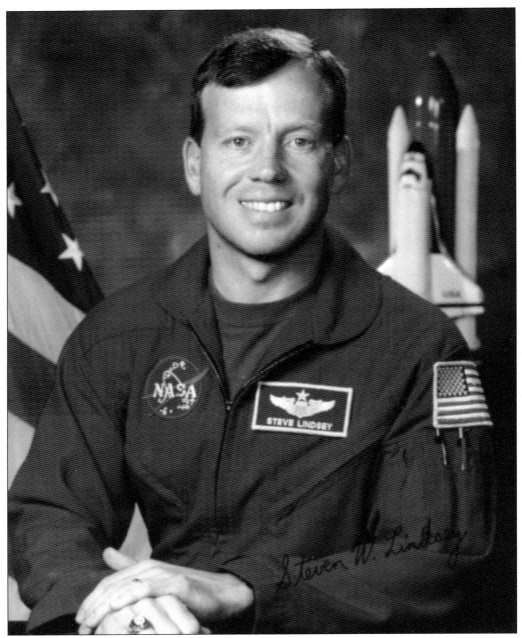

Steve Lindsey was a 1978 graduate of Temple City High School. He attended the Air Force Academy, and in 1995, he was selected to be a NASA astronaut, where he manned five space shuttle flights and logged more than 1,510 hours in space. In 2015, he was inducted into the US Astronaut Hall of Fame.

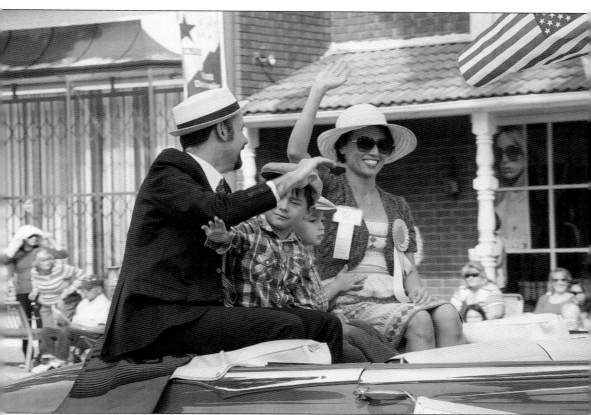

LeUyen Pham is a children's book author and illustrator who has received numerous awards for her books and illustrations. Pham was a student at La Rosa, Cloverly, and Oak Avenue schools and graduated from Temple City High School. In 2014, she was the grand marshal of the Camellia Festival. (Courtesy Temple City Photos.)

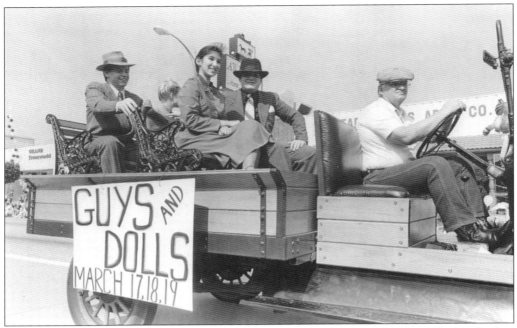

Each year, Temple City High School puts on a musical with performers from all Temple City Unified schools. The musical in 1989 was *Guys and Dolls*. In this photograph, cast members are promoting the event by participating in the Camellia Parade. Since Temple City High School began doing annual musicals, *Guys and Dolls* has been performed three times.

Ramrodder Booster Club has supported the athletic teams at Temple City High School since the early days of the school. Besides advocating for the student-athletes, the club raises money to assist with the school's sports programs. In this photograph, taken in 1989, club members held a car show at Temple City's city hall.

Beginning in 1993, the parents of graduating seniors at Temple City High School began offering an on-campus, all-night graduation party. Temple City High School Grad Nite Committee provides graduates with a safe and fun event on the school's campus. In this photograph from the 1990s, unidentified parents are working on decorations for the event.

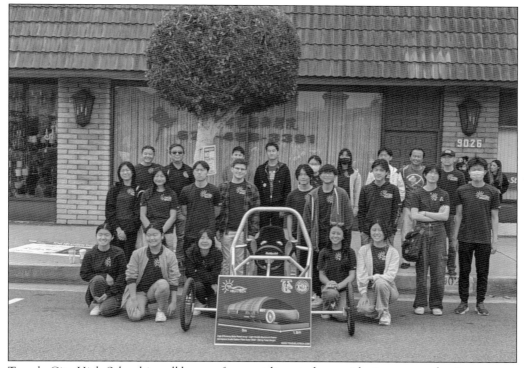

Temple City High School is well-known for providing students with rigorous academic programs and opportunities for extracurricular academic activities. In the 2023–2024 school year, Temple City High School became the third public school in California to offer a solar car program. In this photograph, the students preview their car frame at the Camellia Parade. (Courtesy Vinson Bell.)

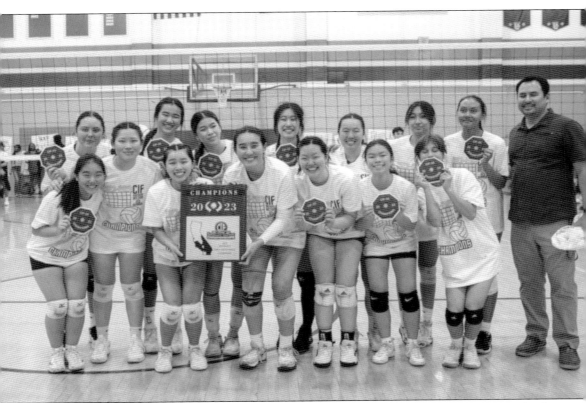

Title IX expanded opportunities for girls to participate in school sports. Since its inception in the 1970s, girls at Temple City High School have excelled in sports. Over the years, the Lady Rams have won many Rio Hondo League and California Interscholastic Federation championships. Pictured is one of Temple City High School's latest standouts: the 2023 Girls Volleyball California Interscholastic Federation champions.

Five

Camellia Festival

It all started in 1944 with a contest held by the Woman's Club of Temple City to choose a flower and a slogan for the community. Mrs. Ralph Saunders submitted the winner, "Temple City Home of the Camellias." In 1945, Sharon Ray Pearson, then eight months old, was crowned queen of Camellia Day and rode in a car down Las Tunas Drive as a handful of Camp Fire Girls gave out camellia blossoms to pedestrians. By 1946, local youth groups formed the Camellia Parade beginning at Rosemead Boulevard, heading east on Las Tunas Drive, and ending at Primrose Avenue. Three toddlers were chosen to serve as queen and princesses. In 1947, it was decided that the royal court should be chosen from local first graders with the idea that after they participated in the Camellia Festival, they would want to belong to one of the city's youth organizations. The next year, youth groups were invited to enter miniature floats, which ranged from decorated buggies and bicycles to plywood mounted on a wagon. Also added that year were a carnival and a coronation pageant.

Each festival thereafter grew in size and popularity. Youth groups improved their floats, and more prizes were added, including a sweepstakes award. Local groups grew in membership, and popular entertainers appeared as grand marshals. For many years, the parade was televised. Temple City soon became famous for its focus on children and promotion of participation in youth organizations.

Eighty years later, the Camellia Festival remains Temple City's premiere community event involving thousands of residents and attracting attendees from throughout Southern California. The Camellia Festival organization is a nonprofit, providing opportunities for school and youth groups to fundraise. The City of Temple City is the official sponsor of the three-day festival that takes place on the last full weekend of February. The royal court consisting of a king, queen, two princes, two princesses, and four banner carriers is selected from first-grade students who reside in the community. A royalty luncheon is held and attended by the public and local dignitaries.

Sharon Raye Pearson, eight months old, was the first queen of the Camellia Festival. She was chosen as the 1945 queen because her mother won the sweepstakes trophy at the chamber of commerce flower show. Baby Sharon rode down Las Tunas in a phaeton car transformed into a camellia-decked bassinet. When she reached Temple City Park, she was greeted by the South Santa Anita School band.

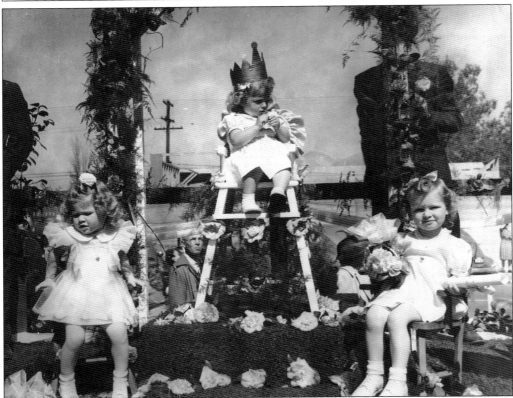

These little girls were the only toddlers to ever serve on the Camellia Festival Royal Court. Queen Nancy Harp and princesses Gail Jean Norton and Cheryl Palmer led the 1946 Camellia Parade. The next year, first graders began making up the royal court, a tradition that continues today. (Courtesy Camellia Festival.)

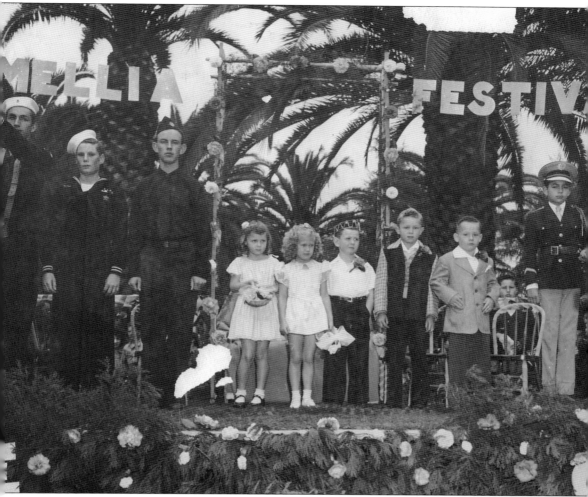

In 1947, the Camellia Festival had its first royal court of first graders. The royal court was made up of king Terry Cushatt, queen Beverly Borger, prince Bill Wherry, princess Mary Lynn Luther, prince Stephen Kennick, and princess Carolyn Lloyd. In this photograph, the children are special guests at an activity in Temple City Park. (Courtesy Camellia Festival.)

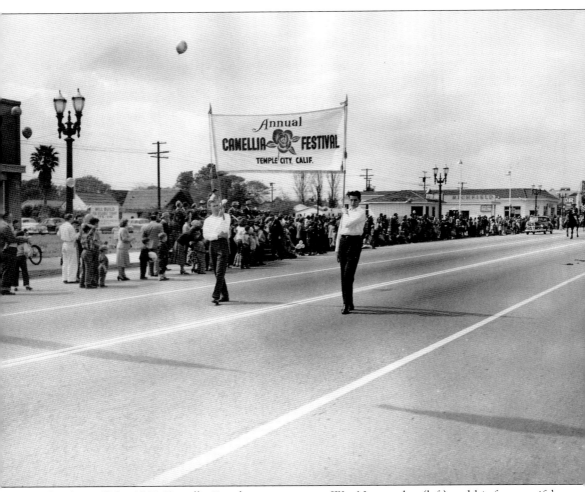

Leading off the 1949 Camellia Parade were teenagers Wes Nunamaker (left) and his future wife's cousin, Kenneth Briggs (right). Nunamaker went on to be the proprietor of Cool's Candies, a popular business in Temple City from 1941 to 1986. Briggs went on to serve two terms as mayor of Temple City. Nunamaker's father also served as mayor of Temple City. (Courtesy Camellia Festival.)

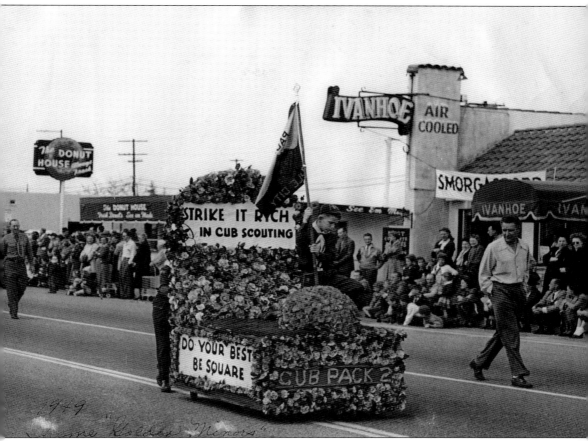

In honor of California's centennial, the theme of the 1949 Camellia Festival was "Golden Miners." Thirty-five floats and over 3,500 participants marched down Las Tunas Drive. In the background of this picture is a new business in Temple City, the Donut House. It was the first donut shop founded by Verne Winchell and soon became known as Winchell's Donut House. (Courtesy Camellia Festival.)

Temple City's motto, "Home of the Camellias," has always played a central role in the Camellia Festival. Many homes in the community have camellia bushes, which are used to decorate the floats in the parade. Camellias are also used as adornments, as they were in this 1949 picture of king Richard Begley and queen Judy Springer. (Courtesy Camellia Festival.)

Around 1950, the American Legion Post 279 entered this float titled "The Wizard of Oz" in the Camellia Parade. Post 279 has played a key role in the community since the early days of the town of Temple, hosting armistice events in Temple City Park and sponsoring Boys and Girls State programs. (Courtesy Camellia Festival.)

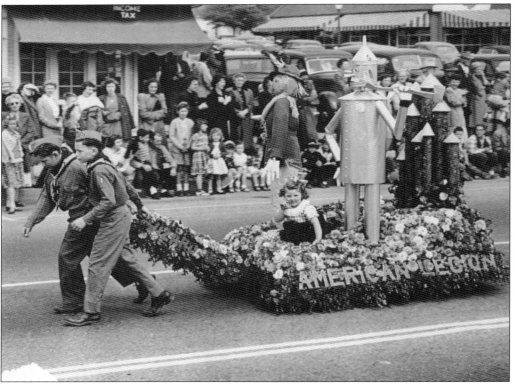

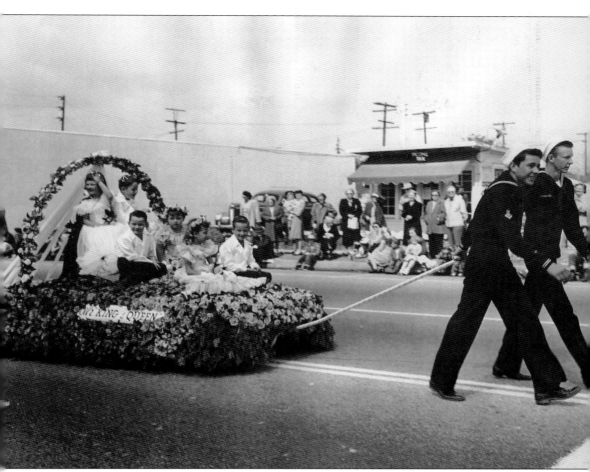

The theme of the 1950 Camellia Parade was "Fairytales in Flowers." In this photograph, king Jackie Paulsen, queen Patsy Ann Hickling, princesses Sharon Rose Rucker and Sunny Sherman Hulsman, and princes Millard Schenck and Chris Delleback are being pulled down Las Tunas Drive by a couple of Navy men. (Courtesy Camellia Festival.)

Jump Jump, the star of a radio show in the late 1940s, was created by Mary and Harry Hickox. In this photograph, Jump Jump is posing with his best friend Merry Holiday (played by Hickox) and the 1953 Camellia Festival queen and king, Terry Ann Abbott and Stephen Holtz. (Courtesy Camellia Festival.)

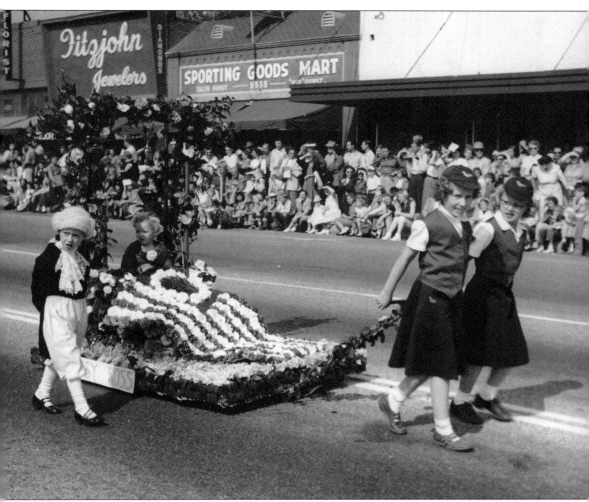

The theme of the 1954 Camellia Festival was "God Bless America." The Camp Fire Girls in this photograph won the sweepstakes trophy in the parade for their float titled "Betsy Ross." The grand marshal that year was country singer Molly Bee, famous for her rendition of "I Saw Mommy Kissing Santa Claus." (Courtesy Camellia Festival.)

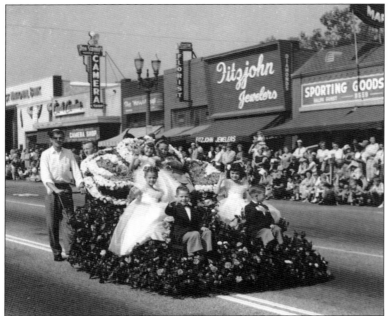

Each year, the royal court rides on a specially decorated float in the parade. In this photograph, the 1954 royal court, made up of king Joe Whitehouse, queen Beth Ann Farry, princesses Marcia Ann Mace and Mary Jo Von Eute, and princes Jeffrey Bundy and Patrick Fehr, are being pushed by local teenagers down Las Tunas Drive. (Courtesy Camellia Festival.)

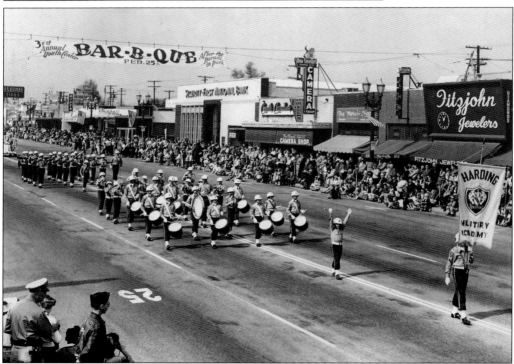

In the early years of the Camellia Festival, the Temple City Community Youth Center Committee hosted a fundraising barbecue after the parade. The committee owned property next to Longden Avenue School that it sold to help fund the swimming pool at Temple City High School. The property later became a baseball field for Temple City National Little League. (Courtesy Camellia Festival.)

This is a c. 1950 photograph of the Camellia Parade with students from Longden Avenue School (formerly South Santa Anita School) marching in the parade. The building in the background (Tempo) has a long history in Temple City. In 1955, the Jambazian family opened Wonder Cleaners at the site. (Courtesy Camellia Festival.)

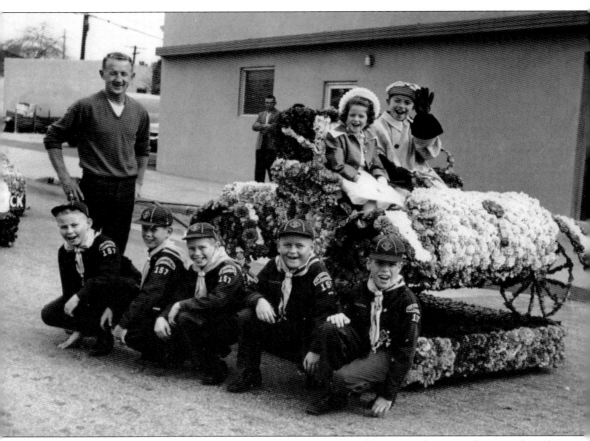

In 1960, Boy Scout Pack 157 entered this float of an old car in the Camellia Parade. The theme of the Camellia Festival was "Have Fun–Will Travel," and the grand marshal was Johnny Crawford of *The Rifleman*. Crawford started his career as one of the original Mouseketeers, and shortly after appearing in the Camellia Parade, he became a popular recording artist. (Courtesy Camellia Festival.)

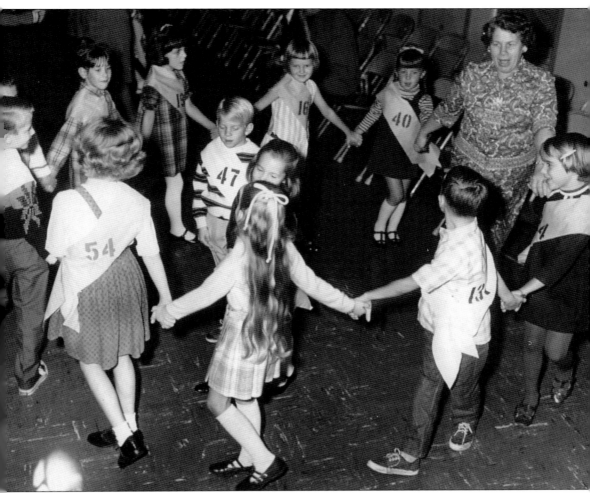

The Camellia Festival Royal Court members are chosen during a play day contest in which they are observed playing games, creating crafts, and talking on a microphone. Children are identified only by a number, and the judges are individuals with no ties to Temple City. The children selected for the royal court are notified by the Camellia Festival committee. (Courtesy Camellia Festival.)

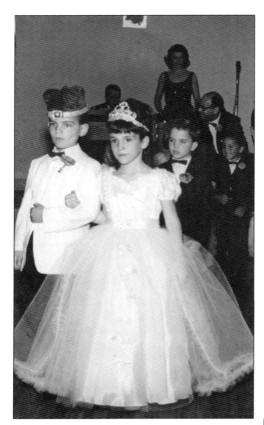

Since the early days of the Camellia Festival, royal court members have been provided with clothing to wear when they make official appearances. Another tradition is that the girls receive a locket necklace to commemorate their time on the court. Pictured are 1964 prince Robert Samarzich and princess Susan Tait. (Courtesy Camellia Festival.)

The theme of the 1963 Camellia Festival was "Rhymes and Riddles." The nursery rhyme "There Was an Old Woman Who Lived in a Shoe" was depicted by Troop 376 with their push float decorated only with parts of the camellia bush. After the parade, the float was on display so that the community could see it up close. (Courtesy Camellia Festival.)

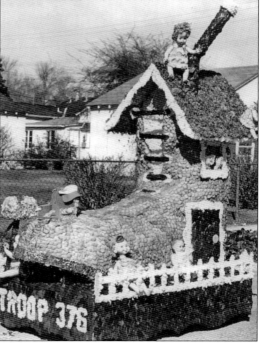

In 1965, Roger Lockie Jr. and Elizabeth Petterson served as king and queen for the 29th annual Camellia Festival. The theme that year was "Temple City Salutes America," and as royal court members, Lockie Jr. and Petterson made numerous public appearances throughout the year and helped crown the 1966 court at the coronation. (Courtesy Camellia Festival.)

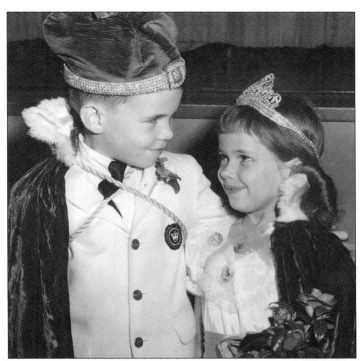

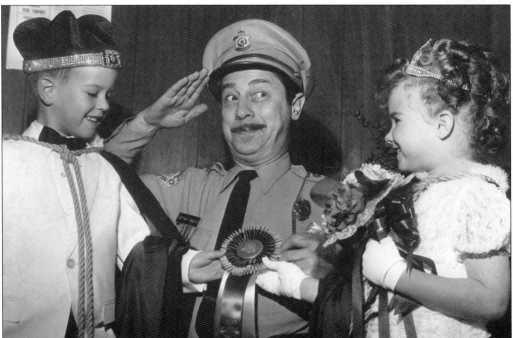

Vito Scotti was the grand marshal of the 1969 Camellia Festival. He played Capt. Gaspar Fomento, the local police officer on the *Flying Nun* television show. In this photograph, he is dressed as his television character and is surrounded by king Jimmy Serven and queen Marilee Seres. (Courtesy Camellia Festival.)

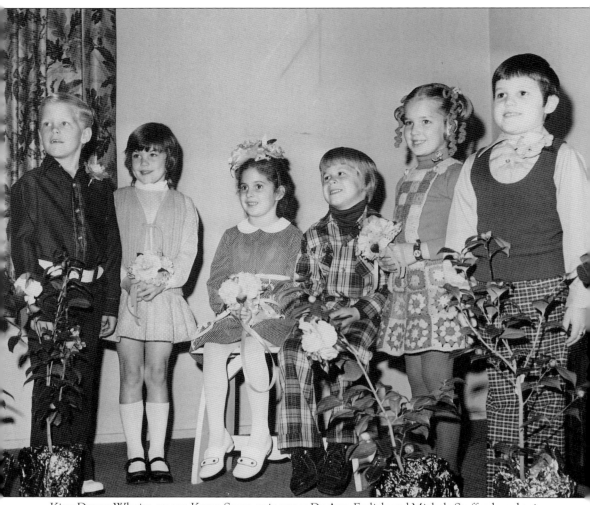

King Danny Whaite, queen Karen Sease, princesses De Ann Fralick and Michele Stafford, and princes Scott Christianson and Brent Hegle made up the royal court for the 1974 Camellia Festival. The general chairman that year was Margie Calamia, an active volunteer with the Temple City Chamber of Commerce, Woman's Club, and the Camellia Festival. (Courtesy Camellia Festival.)

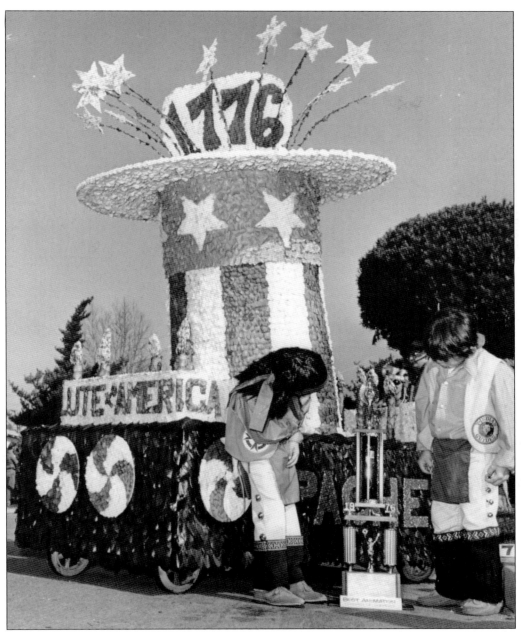

As the United States commemorated the country's bicentennial, Temple City joined in the celebration by choosing "Happy Birthday America" as the theme of the 1976 Camellia Festival. In this photograph, unidentified children admire the trophy they received for their patriotic float of a large Uncle Sam hat with fireworks coming out of the top. (Courtesy Camellia Festival.)

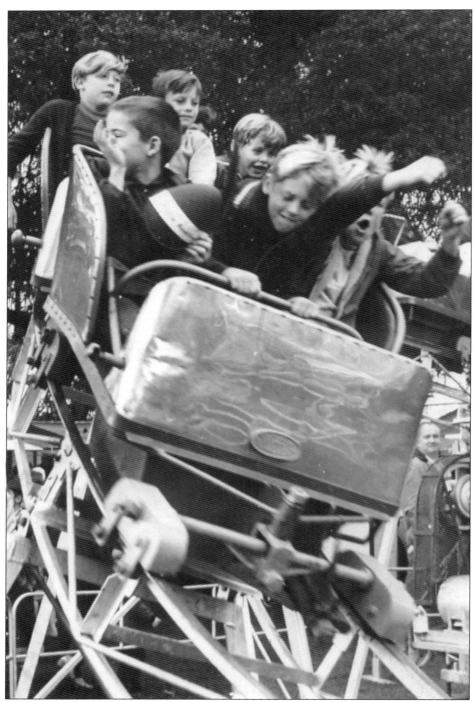

Each year, children anxiously await the opening of the Camellia Festival carnival. Rides, games, food, and entertainment fill Temple City Park for the three-day event. In this photograph, some unidentified children are enjoying a ride on a roller coaster, while one of the boys holds on tightly to his traditional Camellia Festival hat. (Courtesy Camellia Festival.)

The Camellia Festival is held each year on the last full weekend in February. It is the biggest community event held in Temple City thanks to the hundreds of community volunteers, children, and adults alike who engage in all aspects of the festival. In this photograph, an unidentified volunteer is working at a game booth. (Courtesy Camellia Festival.)

For many years, "Peter Pan" hats were a must-have accessory for parade marchers, spectators, and carnival attendees. They most often had a feather and said "Camellia Festival" on them. In this photograph, an unidentified little boy sits on the curb waiting for the parade to come by. (Courtesy Camellia Festival.)

111

The Camellia Festival was established in 1944 "to promote a desire in every child to participate in the affairs of the community." Participation in the parade is limited to youth groups and other organizations that support youth activities in Temple City. Almost every child in Temple City has had the opportunity to march in the parade at one time. (Courtesy Camellia Festival.)

One of the traditions of the Camellia Festival is to have royal court members open the carnival on the first day. In this photograph from 1984, Camellia Festival committee member Bill Swain (front, right) and general chairman Don Kelker (back, center) try out a ride with unidentified members of the royal court. (Courtesy Camellia Festival.)

One of the traditions of the Camellia Parade is that the Temple City High School band leads off the parade. Known as "the Pride of Temple City," the award-winning band serves as the host band and does not compete with the other bands in the parade. This photograph was taken in 1969. (Courtesy Camellia Festival.)

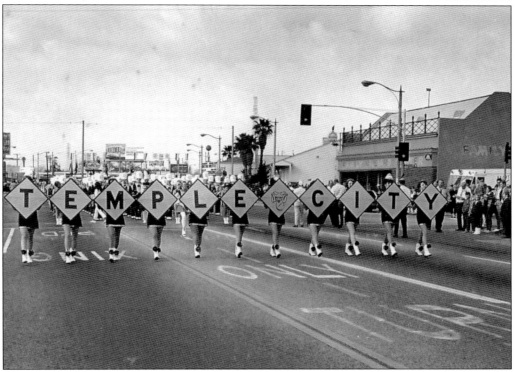

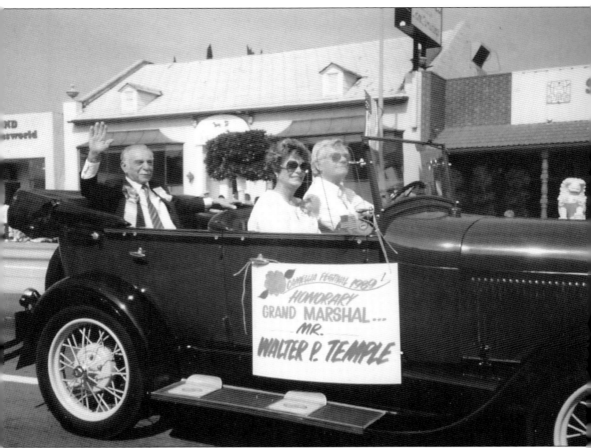

In 1989, the theme of the Camellia Festival was "An Old Time Country Celebration." Walter P. Temple Jr. was the honorary grand marshal of the parade. Although he did not live in Temple City, Temple was involved in many community activities in the town his father founded. Temple died in 1998, and his daughter Josette continued to be active in Temple City until her death in 2020.

Six

THE 1980s TO NOW

Although no members of Walter Temple's family have ever lived in Temple City, his descendants have been active in the community for many years. Walter P. Temple Jr. and his daughter Josette have served as honorary grand marshal and grand marshal of the Camellia Festival. They and other Temple family members have been incredibly supportive of community activities and the preservation of Temple City's history.

Even though the Temple family members have not lived in Temple City, there have been many notable residents. Richard Drew, the 9/11 photographer famous for *Falling Man* grew up in Temple City. David Klein was living in Temple City when he invented the Jelly Belly, as was Phyllis Frelich when she became the first deaf actress to win a Tony Award. Also, Agatha Award–winning author Edith Maxwell grew up in Temple City and was a member of the Camellia Festival Royal Court.

Temple City's population has seen modest growth since its incorporation in 1960. Beginning in the 1980s, the diversity of the community began to change significantly. As of 2022, approximately 65 percent of Temple City's population was of Asian descent. This change in the city's ethnic makeup has brought about opportunities for the community to be exposed to many new cultural experiences. Today, Temple City has highly rated Asian restaurants, and the city government works in cooperation with the Chinese American Association to celebrate traditional Asian events such as the Lunar New Year celebration and Mid-Autumn Festival. The Workman and Temple families were multiethnic and now the town reflects their diversity.

The year 2023 was a special one for Temple City, as the community celebrated the centennial of the town of Temple. The celebration started in May with a banquet organized by the Historical Society of Temple City. In the fall, the city sponsored a parade that disbanded at Temple City Park, where attendees participated in special activities and watched performances by Temple City school groups. Later in the year, Temple City collaborated with the Workman and Temple Family Homestead Museum to provide a special day at the Homestead Museum with special experiences for Temple City residents.

In 1984, the Olympic torch was carried 9,300 miles across the United States, a trek that took almost three months. The route took the torch through Temple City on its way to the Los Angeles Coliseum. As the torch came through town, Temple City residents lined the streets of Rosemead Boulevard and Las Tunas Drive to celebrate the upcoming Olympics.

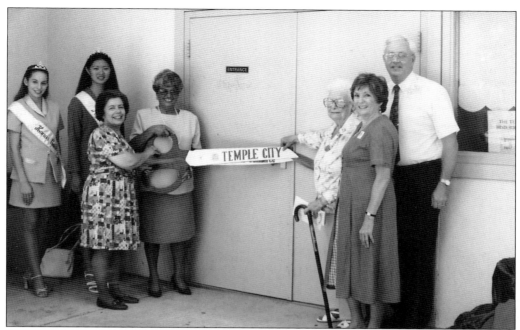

Due to the generosity of the city, the old media building at Live Oak Park was designated as a public museum in 1999. Residents provided many artifacts of historical interest to help with the displays. Holding the scissors at the ribbon cutting for the museum is Josette Temple (third from left), Walter Temple's granddaughter. The museum remained at the park until 2006, when it moved to the Woman's Club building.

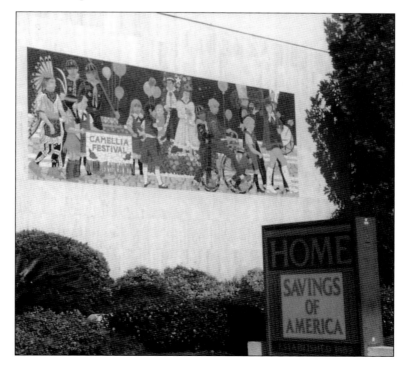

In the 21st century, Temple City developed an interest in public art. The mural in the photograph was designed by the famed artist, teacher, and architectural designer Millard Sheets. It was designed for the Home Savings (now Chase Bank) building on Las Tunas Drive near Rosemead Boulevard. The Temple City mural, depicting the Camellia Parade, is sometimes included in art and architectural tours in Southern California.

117

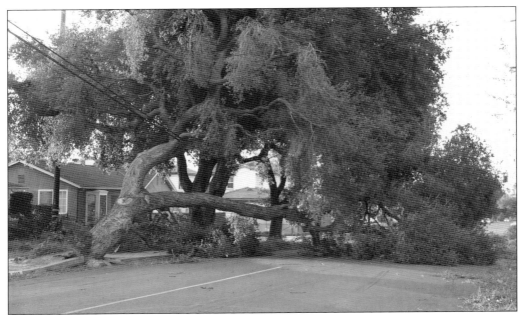

On November 30 and December 1, 2011, wind gusts greater than 70 miles per hour pummeled Temple City, causing the city to open their emergency operations center and declare a local state of emergency. The winds knocked down trees and power lines, blocking streets and causing schools to close. (Courtesy Temple City Photos.)

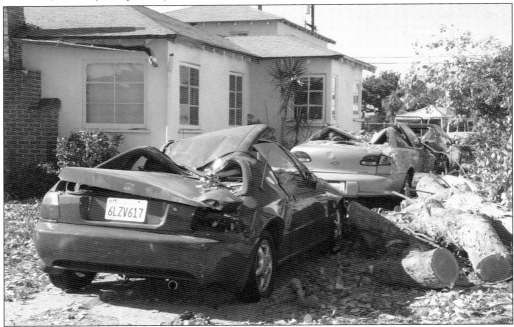

Personal property damage from the 2011 windstorms in Temple City amounted to about $4 million. The resident in this photograph lost two automobiles, and their home sustained damage. Fortunately, no homes in Temple City were red-tagged, and miraculously, there were no serious injuries, although many residents were quite distressed by the event. (Courtesy Temple City Photos.)

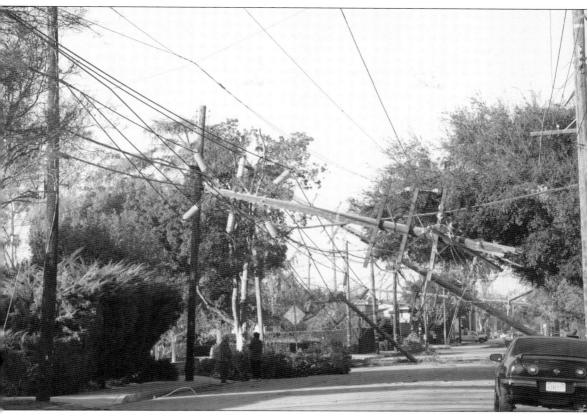

The windstorm of 2011 snapped 17 power poles and numerous transmission lines, with the worst damage along Live Oak Avenue. Many residents were without power for almost a week. The city lost 50 of the beautiful old-growth trees that lined residential streets. Estimated damages in Temple City were $10 million, and it took seven days to remove the bulk of the debris. (Courtesy Temple City Photos.)

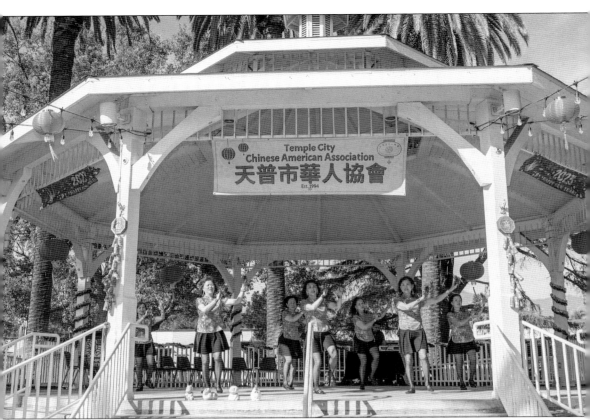

The Temple City Chinese American Association was established to connect, serve, promote, represent, and assimilate the Chinese community in Temple City. Since 1997, the association has participated in many community activities and has sponsored events for the city such as the annual Lunar New Year celebration. (Courtesy Temple City Photos.)

Over the years, the racial composition of Temple City has changed to include more Asian Americans. Temple City has been committed to being an inclusive community and has used the opportunity to offer Asian cultural activities for the community. The three little girls in this photograph attended an activity at Temple City Park in traditional outfits. (Courtesy Temple City Photos.)

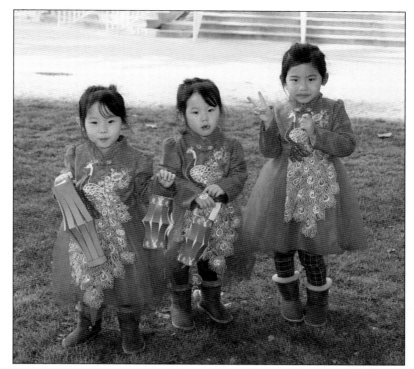

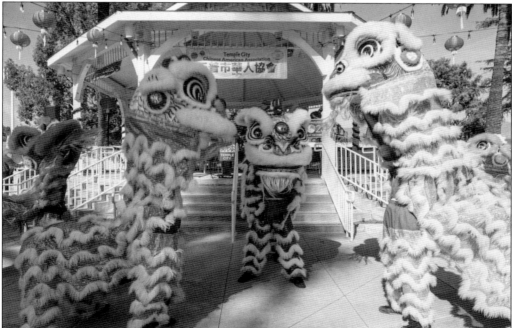

A Lunar New Year event is held each year at Temple City Park. It includes live entertainment, food, children's activities, vendors, and raffles. The highlight of the Chinese New Year celebration is the Lion Dance. The Lion Dance is a traditional dance in which performers mimic a lion's movements in order to bring good luck and fortune. (Courtesy Temple City Photos.)

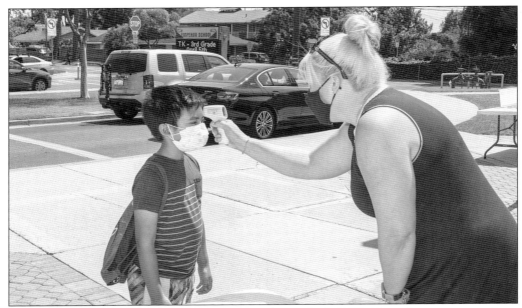

In April 2021, after over a year of virtual learning due to the COVID-19 pandemic, some students in Temple City schools returned to school for in-person learning. With masking, hand sanitizing, social distancing, and temperature taking, it was a happy day for students, parents, and teachers. The remaining students were invited back to school a few months later in August. (Courtesy Temple City Photos.)

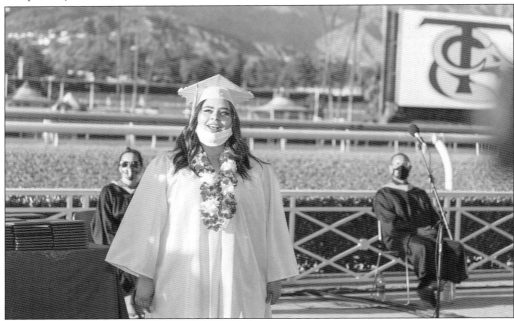

Due to the COVID-19 pandemic, members of the Temple City High School class of 2020 had a drive-through graduation. In order to offer a safe graduation ceremony for the 2021 graduating class, the ceremony was moved from the high school football field to Santa Anita Racetrack. In this photograph, Alexa Espinoza smiles as she receives her diploma. (Courtesy Temple City Photos.)

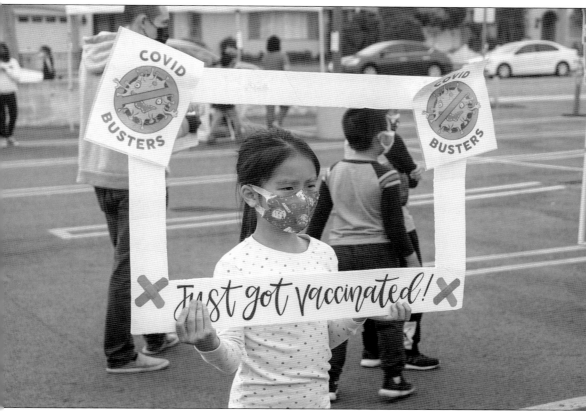

During the COVID-19 pandemic, the Temple City Unified School District, in partnership with Herald Christian Health Center, conducted regular vaccination clinics in the district office parking lot for staff and students. After reopening for in-person learning, the Temple City Virtual Academy was established to accommodate those students not ready to return to in-person school. (Courtesy Temple City Photos.)

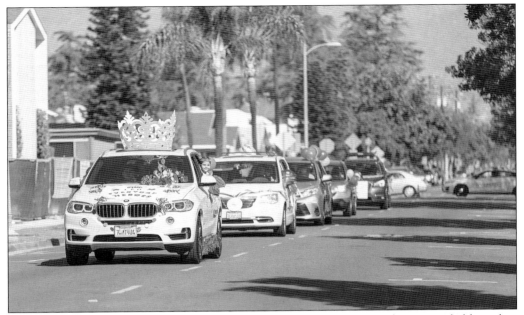

Even though there was not an in-person Camellia Festival in 2021, a virtual event was held to select a royal court for a video parade. The royal court members were interviewed as their car drove down Golden West Avenue between Woodruff Avenue and Las Tunas Drive for the filming of the video parade. (Courtesy Temple City Photos.)

The COVID-19 pandemic forced the Camellia Festival to go virtual in 2021. In order to keep the tradition alive, a short parade with a royal court and city dignitaries was videotaped and streamed to the community. The next year, the pandemic forced the festival and parade to be postponed until May, when it could safely be held in person. (Courtesy Temple City Photos.)

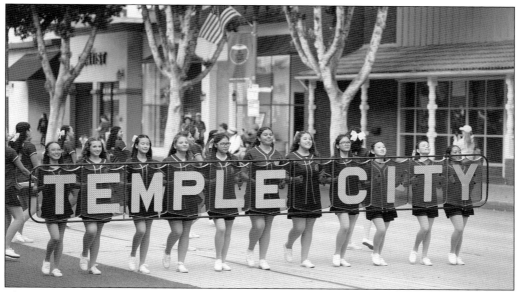

The year 2023 was the centennial of the founding of the town of Temple. Temple City celebrated with many activities, including a parade down Las Tunas Drive on September 30. The Temple City High School marching band led off the parade, and it included participants from Temple City youth groups, service organizations, and schools. (Courtesy Temple City Photos.)

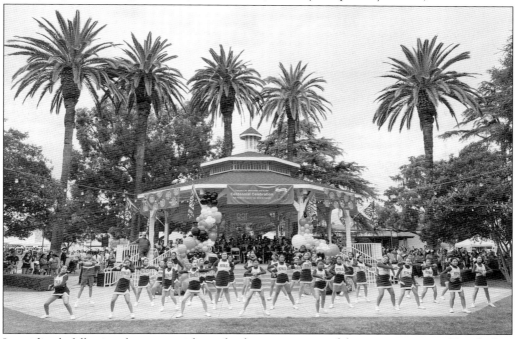

Immediately following the centennial parade, there were many celebratory activities in Temple City Park. Members of the Oak Avenue Royalette Auxiliary team performed, along with other school and community groups. There were bounce houses and crafts for the children, and the Workman and Temple Family Homestead Museum offered talks on the history of Temple City. (Courtesy Temple City Photos.)

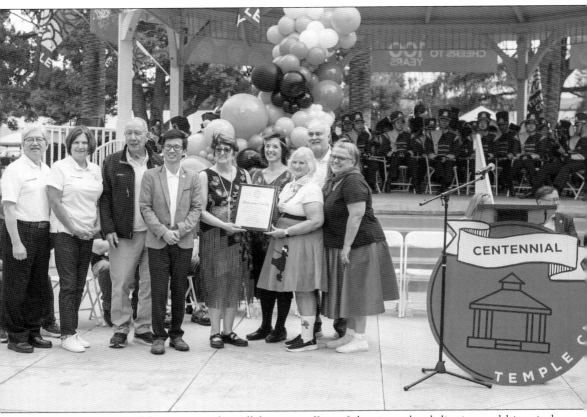

The centennial celebration was the collaborative effort of the city, school district, and historical society. In this photograph, members of the city council (Vincent Yu, Cynthia Sternquist, William Man, Fernando Vizcarra, and Tom Chavez) present board members of the Historical Society of Temple City (Mary Sneed, Dawn Tarin, Debi Mistretta, and Mitzi Franco) with a commemorative certificate. From left to right are Yu, Sternquist, Vizcarra, Man, Sneed, Tarin, Mistretta, Chavez, and Franco. (Courtesy Temple City Photos.)

Beginning in the 1970s, flocks of red-crowned parrots began making their home in Temple City. No one knows for sure how the Latin American birds came to the area, but the parrots have thrived due to the abundance of fruit and flowering trees in Temple City. Despite their sometimes rude squawking, Temple City has embraced the beautiful birds and even created a special parrot logo. (City of Temple City.)

Discover Thousands of Local History Books
Featuring Millions of Vintage Images

Arcadia Publishing, the leading local history publisher in the United States, is committed to making history accessible and meaningful through publishing books that celebrate and preserve the heritage of America's people and places.

Find more books like this at
www.arcadiapublishing.com

Search for your hometown history, your old stomping grounds, and even your favorite sports team.

Consistent with our mission to preserve history on a local level, this book was printed in South Carolina on American-made paper and manufactured entirely in the United States. Products carrying the accredited Forest Stewardship Council (FSC) label are printed on 100 percent FSC-certified paper.